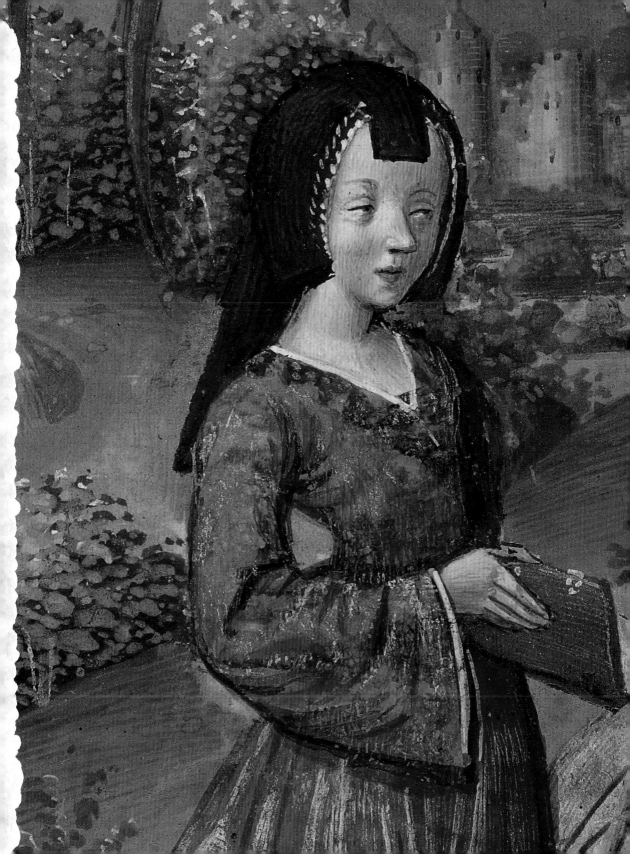

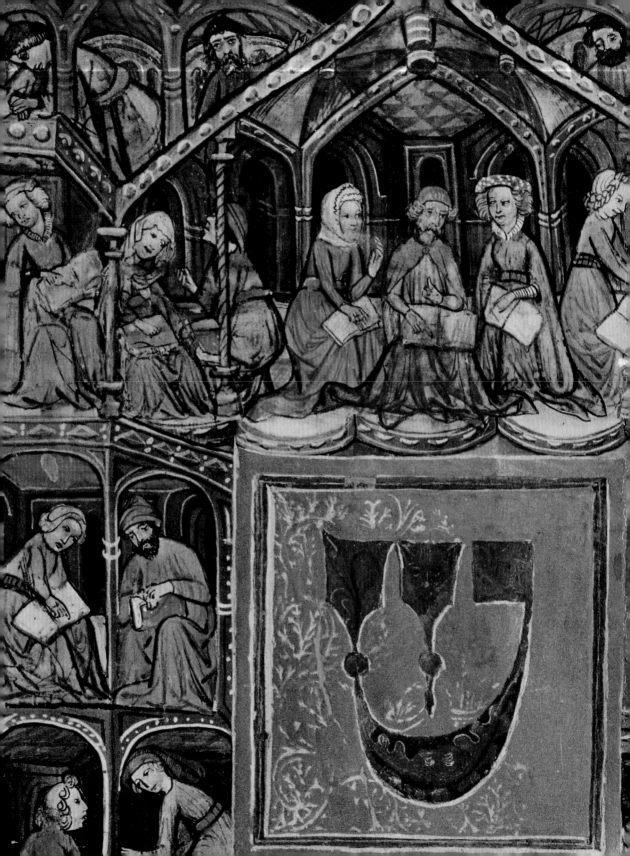

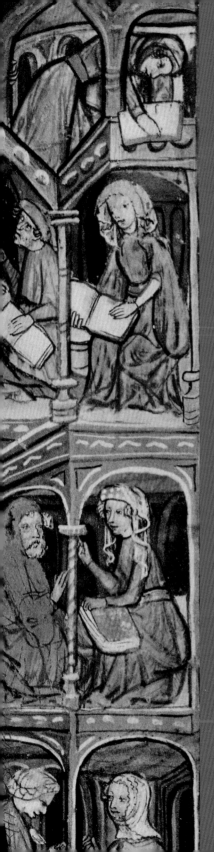

Illuminating
WOMEN
IN THE MEDIEVAL WORLD

Christine Sciacca

THE J. PAUL GETTY MUSEUM ᷟ LOS ANGELES

CONTENTS

CHAPTER ONE

MEDIEVAL IDEALS OF WOMANHOOD

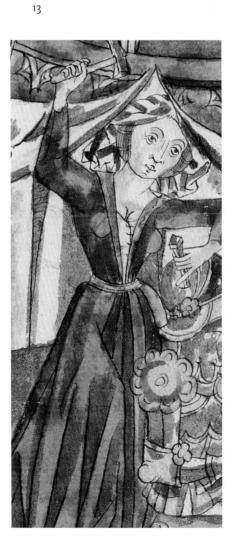

CHAPTER TWO

WARNINGS TO MEDIEVAL WOMEN

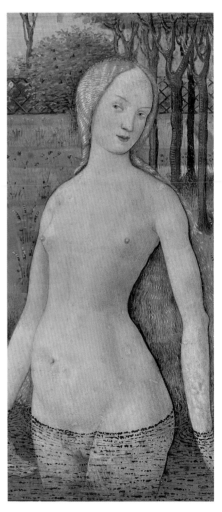

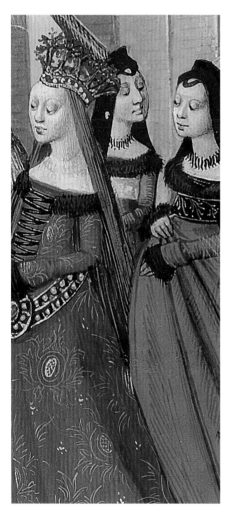

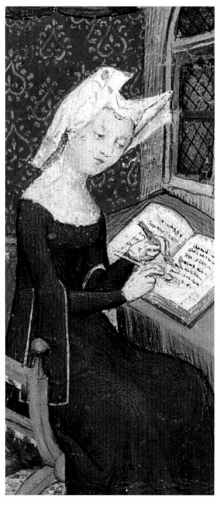

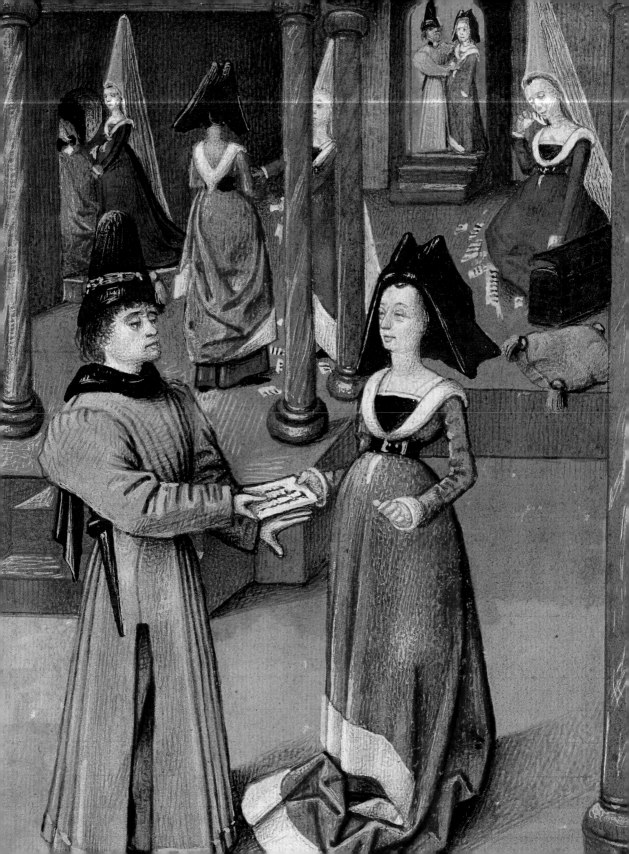

FOREWORD

Nearly nine hundred years ago, in medieval France, Peter Abelard and Heloise d'Argenteuil became lovers, engaging in an ill-fated affair that, through their correspondence, has provided modern-day readers with an intimate insight into an extraordinary medieval woman. Their relationship began when Abelard became Heloise's tutor and seduced her, after which they had a child out of wedlock, entered into an unhappy forced marriage, and eventually separated, with Heloise taking religious vows. After she took the veil, they began their now-famous correspondence, which details in uniquely revealing terms their passionate relationship. More recent study has focused on Heloise's scholarly training, the literary merit of her writing, and her proto-feminist views. Her clear and forthright letters are unusual records of a learned woman's thoughts on the traditional role of women in medieval society, views which were often diametrically opposed to those of the male-dominated church and state. But Heloise was not alone: *Illuminating Women in the Medieval World* draws out other such female voices from the medieval past, highlighting both the prominent and the overlooked.

The Getty's Manuscripts Department last treated the theme of medieval women over twenty years ago in the exhibition *Devotion and Desire: Views of Women in the Middle Ages and Renaissance*. Given the significant advances in both medieval and gender studies over these years, this re-examination by Christine Sciacca of the role of women in medieval society through the lens of illuminated manuscripts is well and truly due. The Getty's collection of manuscripts ranging from across Europe and the Mediterranean world over seven centuries provides many outstanding representations of medieval women that exemplify their varied identities through both text and image. It also contains numerous examples of books commissioned and illuminated by women—signaling their active role in generating a literary and visual record of their own lives and aspirations, as well as their concerns and constraints. The illuminations from Getty manuscripts are complemented by a number of compelling examples from other public and private collections, notably the T. Robert and Katherine States Burke collection and the Ferrell collection. We are much indebted to these and all the lenders for their support of this timely and relevant exhibition.

Timothy Potts, Director
The J. Paul Getty Museum

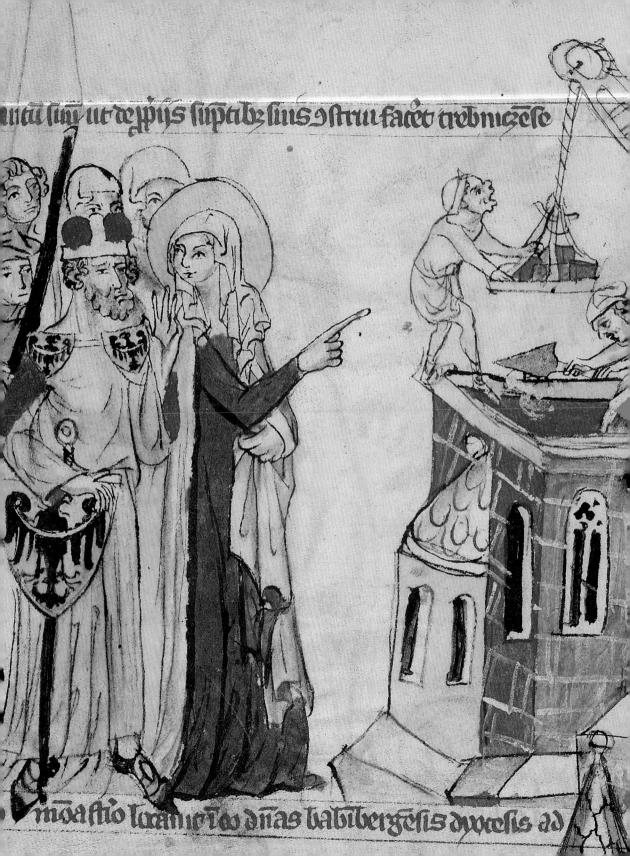

...utu sunt ut de pfis suptibs sins construt faciet trebuneses

moasto locanie tos dnas babibergeñs dyresis ad

ACKNOWLEDGMENTS

℘ FOR OPHELIA VITA

Though women formed an integral part of medieval society, records of their deeds and desires are relatively few. Illuminated manuscripts offer glimpses into the lives of women in the Middle Ages, as well as insights into the various ways in which women were presented to the contemporary reader. The topic of medieval women has drawn the attention of modern scholars for decades. I am grateful to the following colleagues for their suggestions of relevant books and articles: Elizabeth Morrison, Kristen Collins, Bryan Keene, Alexandra Kaczenski, and Rheagan Martin in the Getty Manuscripts Department, as well as Mariah Proctor-Tiffany, Andrea Herrera, Justin Clegg, and Nancy Turner. I am also indebted to Laura Horan and Isabel Diaz Brady, who helped gather the textual resources and the images and their captions.

In Publications, many thanks are due to Ruth Evans Lane and Rachel Barth, who offered their astute editorial skills and invaluable advice for shaping the presentation of this complex topic. Kurt Hauser contributed the elegant design, Amita Molloy oversaw the production with great care, and Gregory Dobie meticulously proofread the text. Michael Smith, Johana Herrera, Kayla Kee, Sarah Rivers, Rebecca Truszkowski, Rebecca Vera-Martinez, Pam Moffat, and Randy Dodson ensured the high quality of the images reproduced here. Finally, I am grateful to Timothy Potts, Richard Rand, Kara Kirk, and Karen Levine for their enthusiasm about this project from its inception. And to Dominic Mimnagh for his enduring support, as we work together to raise a remarkable little woman.

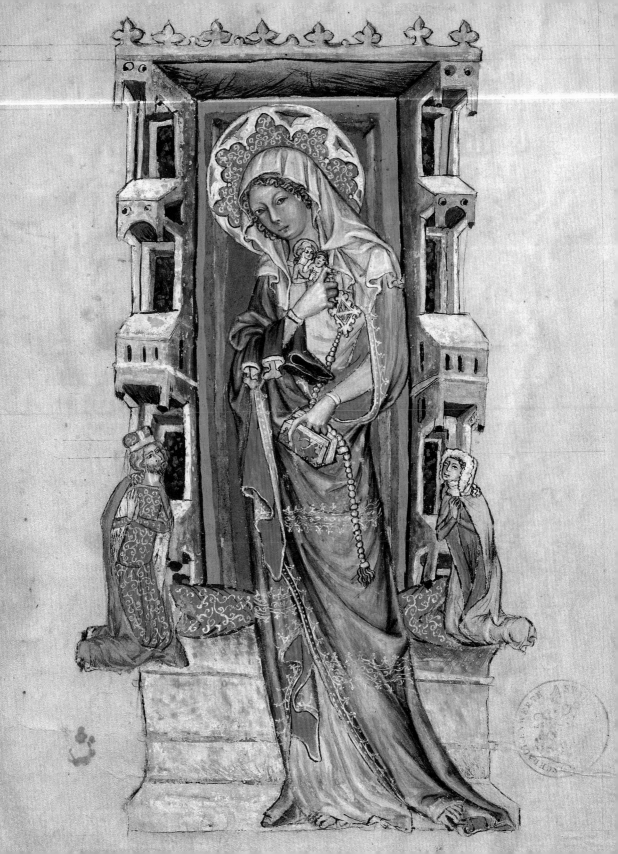

INTRODUCTION

t the age of twelve, Hedwig of Silesia married the future Duke Henry of Silesia, a thirteenth-century monarch of a region in modern-day Poland (fig. 1). She raised seven children, one of whom died in battle, and assisted her husband in resolving his war efforts by negotiating a peace accord with a duke from a neighboring region. Thereafter, she and her husband took vows of chastity, and she shifted focus to her devotion to God. She cared and provided for the sick and the poor, sponsored numerous religious houses, eventually took the Cistercian monastic habit after her husband's death, and performed miracles, both while living and from the afterlife. Saint Hedwig's remarkable trajectory led her through many of the varied prescribed roles that women in the Middle Ages played: wife, mother, political negotiator, charitable patron, pious laywoman, and saint.

The story of Hedwig offers a counterpoint to our modern notion of women in the Middle Ages. This subject conjures up images of damsels in distress, mystics in convents, female laborers in the field, and even women of ill repute—individuals who often held a secondary place in medieval society. We might envision the helpless and beautiful princess about to be devoured by a fierce dragon, until she is rescued at the last moment by Saint George on horseback with his sword raised (fig. 2). In reality, however, the lives of medieval women were nuanced and varied and reflected the diverse geographic, financial, and religious circumstances in which they lived. While more-stereotypical medieval women did exist, we also encounter unexpected examples of women of power and influence, in both overt and subtle ways. The pages of illuminated manuscripts reveal to us the many facets of medieval womanhood and provide insights into medieval life and contemporary attitudes toward women.

1 Saint Hedwig of Silesia with
 Duke Ludwig I of Liegnitz and
 Brieg and Duchess Agnes
 Artist Unknown
 The Life of the Blessed Hedwig
 Silesia, Poland, 1353
 JPGM, Ms. Ludwig XI 7 (83.MN.126),
 fol. 12v

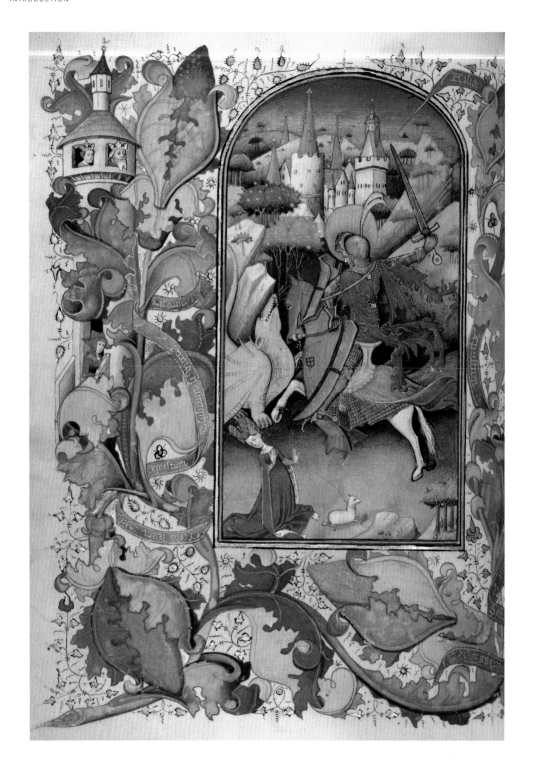

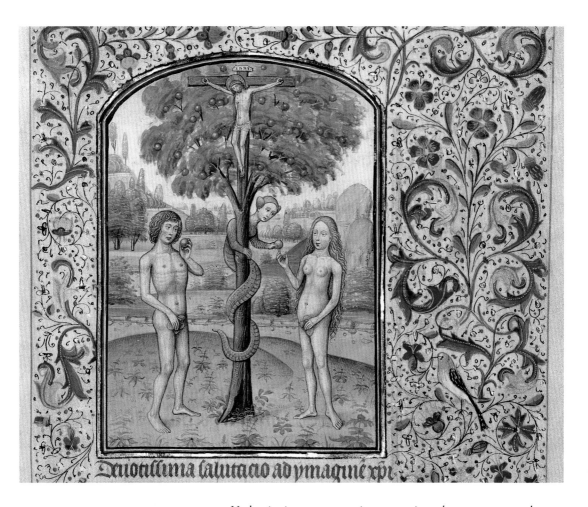

Deuotissima salutacio ad ymaginem xpi

2 Saint George and the Dragon
Master of Guillebert de Mets
Book of hours
Probably Ghent, about 1450–55
JPGM, Ms. 2 (84.ML.67), fol. 18v

**3 Adam and Eve Eating the
Forbidden Fruit**
Willem Vrelant
Arenberg Hours
Bruges, early 1460s
JPGM, Ms. Ludwig IX 8 (83.ML.104),
fol. 137

Underpinning many negative conceptions about women was the Judeo-Christian story of the Creation of the World. In the Garden of Eden the serpent tempted Eve to partake of the forbidden fruit of the Tree of Knowledge, which she ate and then shared with Adam, causing them both to be expelled from paradise and condemning Adam to toil in the fields and Eve to the pain of childbirth. Medieval authors and theologians largely blamed Eve for this indiscretion, which, according to Christian belief, caused subsequent generations to be born with original sin. Some placed the blame on the serpent, but even the snake was often depicted in medieval imagery with a woman's face (fig. 3). As a result, in part, women were thought by many to be weak in character, unable to select the best course of action, and in need of guidance.

The first chapter of this book, "Medieval Ideals of Womanhood," focuses on the ideals that were established for medieval women to aspire to, which are often displayed in manuscript illumination. Biblical heroines, female saints, and pious nuns were held in high regard as models for proper behavior. Virtues, as portrayed in medieval allegorical stories, were often depicted in the form of women who acted as personifications of these ideals. The second chapter, "Warnings to Medieval Women," discusses examples of lascivious women, highlighting figures like the Whore of Babylon and Eve, who were used as warnings against sinful conduct. Sometimes admirable and contemptible women were juxtaposed in the same image by way of instruction (fig. 4). Within this Initial *I* are the two wives of the Persian King Ahasuerus: below is his first wife, the banished Queen Vashti, who held a separate banquet just for the women of the court and disobediently refused the king's request to appear naked before his own dinner guests, and above is his second wife, Queen Esther, who succeeded in interceding on behalf of her Jewish people and saving their lives. Especially popular in medieval imagery was the figure of Mary Magdalene, the quintessential example of an adulterous woman who redeemed herself by becoming Christ's follower and abandoning her previous errant ways. In many medieval images, she holds her attribute, an ointment jar, which alludes to her anointing of Christ's feet with costly oil at a banquet at the home of Simon the Pharisee (fig. 5). After Jesus's death, Mary Magdalene retreated into the wilderness and devoted herself to a life of prayer. Shown at the end of her life in this image from the Gualenghi-d'Este Hours, she is lifted up to heaven by angels to receive her final Communion, and her long hair covers her naked form, a reminder of her past sinful life (fig. 6).

4 Initial *I*: Esther before King Ahasuerus
and the Offended Queen Vashti
Artist Unknown
Bible
Bologna, about 1280–90
JPGM, Ms. Ludwig I 11 (83.MA.60),
fol. 222v

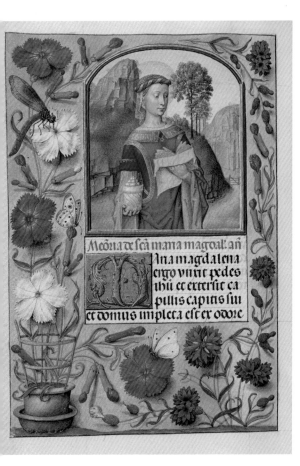

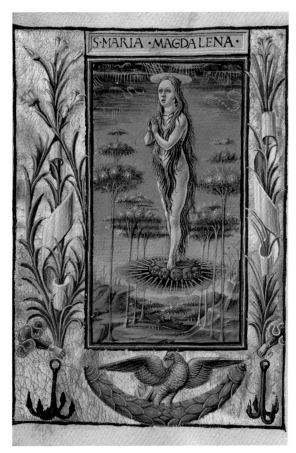

5 Mary Magdalene with a Book
 and an Ointment Jar
 Workshop of the Master of the
 First Prayer Book of Maximilian
 Spinola Hours
 Bruges and Ghent, about 1510–20
 JPGM, Ms. Ludwig IX 18 (83.ML.114),
 fol. 264v

6 Mary Magdalene Borne Aloft
 Taddeo Crivelli
 Gualenghi-d'Este Hours
 Ferrara, about 1469
 JPGM, Ms. Ludwig IX 13 (83.ML.109),
 fol. 190v

Chapter 3, "Medieval Women in Daily Life," examines women's roles in daily life in the Middle Ages, especially their relationships with men, other women, and children. The romantic role of lovers, the powerful social and political function of wives, and the nurturing capacity of mothers were often highlighted in medieval manuscripts. The cult of the Virgin Mary grew. Apocryphal stories about her life became widely read, and popular devotion to her mother, Saint Anne, blossomed, prompting the inclusion of prayers dedicated to her in medieval books of hours. The two were often depicted together, representing the ideal mother-daughter relationship in everyday situations, like this depiction of Anne teaching the youthful Mary to read (fig. 7). This reflects the practice of literate mothers and fathers of wealthier classes teaching their children to read, often using prayer books as primers. Jewish and Muslim families in

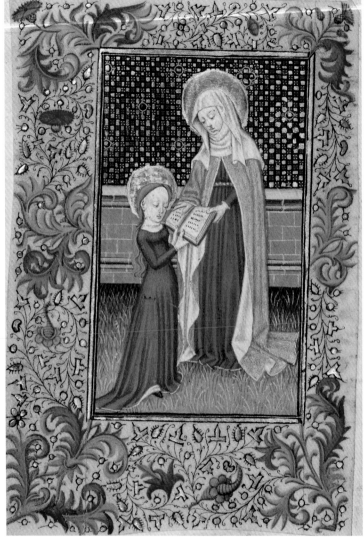

7 **Saint Anne Teaching the Virgin to Read**
Master of Sir John Fastolf
Book of hours
France or England, about 1430–40
JPGM, Ms. 5 (84.ML.723), fol. 45v

8 **Women Reading and the Passover Seder**
Artist Unknown
Haggadah
Middle Rhine, first half
of the fifteenth century
Darmstadt, Universitäts- und Landes-
bibliothek, Cod. Or. 8, fol. 37v

particular also took care to teach their daughters to read scripture. This
emphasis on learning among Ashkenazi Jewish communities in Germany
is depicted in a Haggadah (a book of readings for the Passover Seder) that
was possibly made for a woman, in which numerous women hold open
books and converse with male scholars (fig. 8). Medieval manuscripts also
showed women as an integral part of the economy, as in this illumination
from the Spinola Hours with their active participation in the threshing
of wheat in November after the annual harvest (fig. 9). Though they are

A .Oartini ppe rvj o vigit
rru b Siucti cpi v c Anorce apli
j c Scraphioio

still arguably idealized in various ways, these images of daily life reveal the
important functions of women in medieval society.

The final chapter, "Medieval Women in the Arts," shows that beyond
the narratives told in the pages of manuscripts, women of great wealth
and high social status often exercised their power and influence through
the objects they commissioned, especially books. In this image from the
Llangattock Hours, a woman wearing an elaborate headdress and low-cut
gown in the height of fifteenth-century Flemish fashion is shown kneel-
ing at the feet of the Virgin and Child and holding her chemise-bound
prayer book open for reading (fig. 10). This demonstrates not only her
piety but also her financial ability to commission a luxury object like a
book of hours. Due to their costly materials and the care and skill needed
to write and construct them, manuscripts were some of the most expen-
sive art objects that one could buy in the Middle Ages. Books owned by

9 Threshing and Pig Feeding
Workshop of the Master of James IV
of Scotland
Spinola Hours
Bruges and Ghent, about 1510–20
JPGM, Ms. Ludwig IX 18 (83.ML.114),
fol. 6v

10 The Virgin and Child Enthroned
with a Kneeling Woman
Master of Wauquelin's Alexander
or Workshop
Llangattock Hours
Bruges, 1450s
JPGM, Ms. Ludwig IX 7 (83.ML.103),
fol. 43v

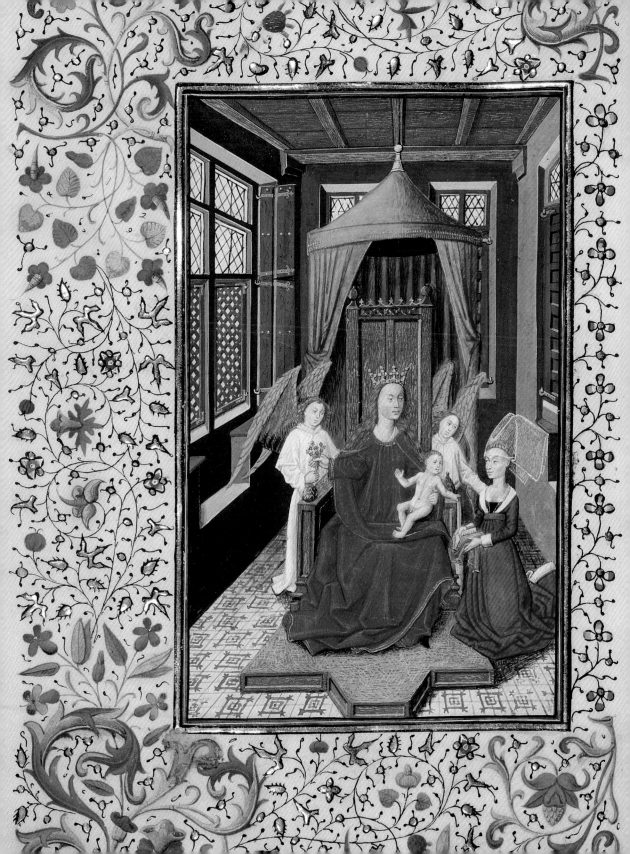

laywomen tended to be heavily illustrated and were sometimes wrapped in luxurious textiles, which further increased their value, as depicted in the Llangattock Hours. The Getty collection contains several books that display evidence of being commissioned by or for female owners, some of whom are identifiable. While many of these patrons' names are now lost, several books are marked with women's coats of arms, mottoes, and portraits, thereby creating a lasting record of their manuscript ownership. An examination of these manuscripts offers invaluable glimpses into the intellectual and devotional lives of such medieval women, revealing the histories, romances, and prayers they read and the models set forth for them that encouraged them to be dutiful wives, loving mothers, and pious, faithful Christians.

In addition to commissioning books, some medieval women also created them. While men dominated artistic workshops in the Middle Ages, female artists, such as the Parisian illuminator Jeanne de Montbaston, were instrumental in the creation of manuscripts (see fig. 95). More so than with any other type of object, women had a special relationship with books. Manuscripts, especially personal prayer books, were thought to be appropriate items for wealthy women to own, and they both commissioned them and gave them as gifts to mark special occasions, such as marriages and births. Because their book collections were often smaller than men's libraries, especially male rulers who inherited royal family holdings, it has been suggested that women had a much more intimate and personal interaction with their volumes than did men. As readers, commissioners, and makers of manuscripts, women saw in the pages of their books both a reflection of their daily lives and role models to whom they should aspire. The pages that follow will illuminate the vibrant and complex medieval portrayal of the women, real and imagined, who fill the texts and images of medieval manuscripts.

Detail, fig. 40

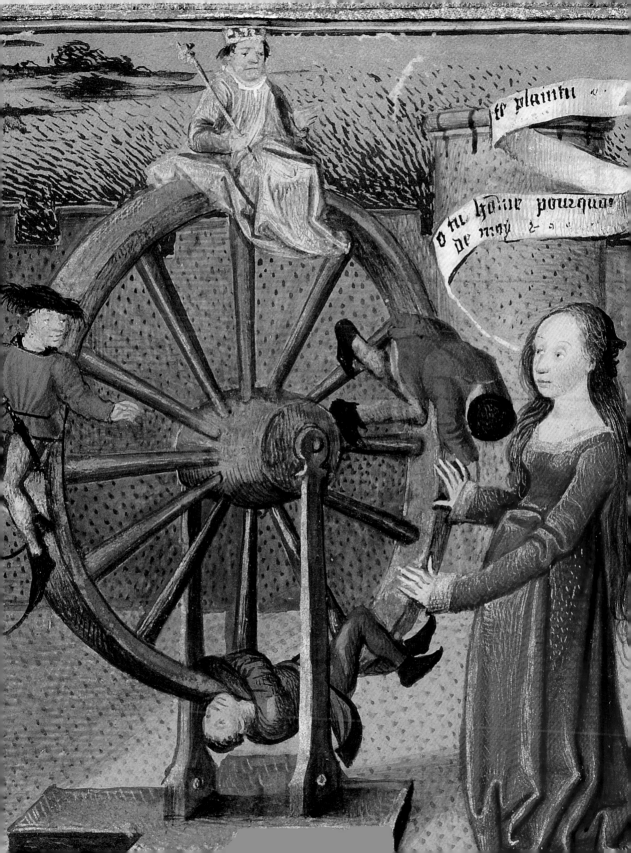

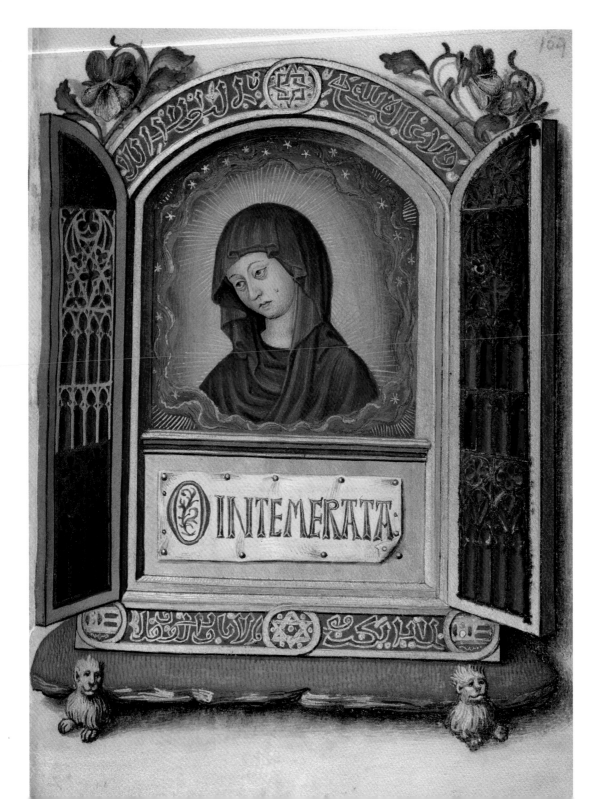

O INTEMERATA

CHAPTER ONE
MEDIEVAL IDEALS OF WOMANHOOD

T he woman who featured most prominently in the Christian Bible was the Virgin Mary—the mother of Christ and the ultimate model for medieval Christians. Her obedience to God, her conception of Jesus without sin, and her love for her son from his childhood through his death on the cross all set an example for the faithful to follow. As a result, many manuscript illuminations from prayer books to history manuscripts depict events from her life, especially in relation to Christ's childhood and Passion (see figs. 16–19). A striking miniature from a late fifteenth-century book of hours presents a different, non-narrative conception: a bust-length portrait of the Virgin Mary encircled by a golden aureole and set within a fictive golden frame like those used to enshrine devotional paintings or icons (fig. 11). George Trubert copied this image from a Byzantine icon owned by René I of Anjou, for whom he was court painter. By the late Middle Ages in western Europe, Mary's status as a role model and subject of devotional attention was so well established that narrative details could be stripped away, shifting the focus to her humanity, shown here by the tear, which she shed for her son, running down her cheek.

The numerous female personalities found in the Hebrew Bible also became frequently used examples to which medieval women were encouraged to aspire. These women were praiseworthy in various ways—demure, obedient, and not overly ostentatious, but also often powerful, courageous, and strong-willed. Many of them, like Judith and Jael, leveraged their sexuality to catch men off guard with their feminine wiles, while still ultimately maintaining their chastity and dignity (see figs. 14, 15).

11 Portable Altarpiece with
the Weeping Madonna
George Trubert
Book of hours
Provence, about 1480–90
JPGM, Ms. 48 (93.ML.6), fol. 159

Numerous female saints also served as models for both Christian men and women alike in the Middle Ages. Many of the most popular, such as Santa Barbara (see fig. 23), Saint Catherine of Alexandria (see figs. 24, 25, 83), and Saint Margaret (see fig. 26), were from the early Christian era in the Roman Empire and were sometimes grouped together in images, as in the illuminated litany from the Ruskin Hours (fig. 12). Frequently, these holy women were horrifically tortured and martyred because of their devotion to God and their refusal to worship pagan gods, or because they refused to marry a pagan man. Other sources of female role models were exceptionally pious women who lived during the Middle Ages, such as Saint Elizabeth of Hungary (1207–1231) (see fig. 30) and Saint Hedwig of Silesia (1174–1243) (see figs. 1, 28, 29, 66), who provided contemporary and relatable examples for medieval women and men to follow. In some extraordinary cases, holy women such as Hildegard of Bingen (1098–1179) (see fig. 94) and Saint Bridget of Sweden (1303–1373) (fig. 13) received visions, which they recorded, and which were translated, disseminated, and widely read by the Christian faithful during the lifetimes of these remarkable women.

Medieval women who took religious vows were also revered. These women sometimes became nuns because their families could not afford the large dowries that would allow them to marry, but they nonetheless dedicated their lives to prayer, acts of charity, and devotion to God. Nuns of various religious orders were depicted in books and held up as models, often for the convents that possessed and used these manuscripts (see figs. 32, 33). It was also in these convents in the early Middle Ages that female literacy was first taught and encouraged, eventually spreading to the royalty, the nobility, and the middle class.

Abstract concepts such as the Seven Virtues and Seven Vices were topics that were frequently treated by medieval authors and artists, who used the female figure to represent these subjects in concrete form. Female personifications of the virtue of Charity (see fig. 36) or the Seven Liberal Arts (see fig. 41) appear in secular and liturgical manuscripts alike, with the women often dressed at the height of fashion for the era in which the book was made. Using the guise of noble or upper-class women for these personifications mirrored the identities of the wealthy owners of these books and reflected back to them the ideals of womanhood.

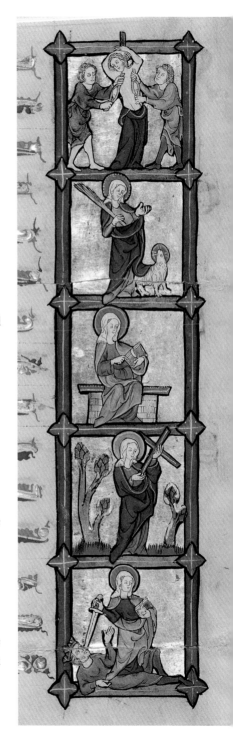

12 The Martyrdom of Saint Agatha;
 Saint Agnes; Saint Cecilia; Saint Lucy;
 Saint Catherine
 Artist Unknown
 Ruskin Hours
 Northeastern France, about 1300
 JPGM, Ms. Ludwig IX 3 (83.ML.99),
 fol. 105v

13 Saint Bridget's Eucharistic Vision
 Artist Unknown
 Devotional miscellany
 Naples, last quarter of the
 fourteenth century
 New York, The Morgan Library &
 Museum, Purchased by J. Pierpont
 Morgan, 1912, MS M.498, fol. 4v

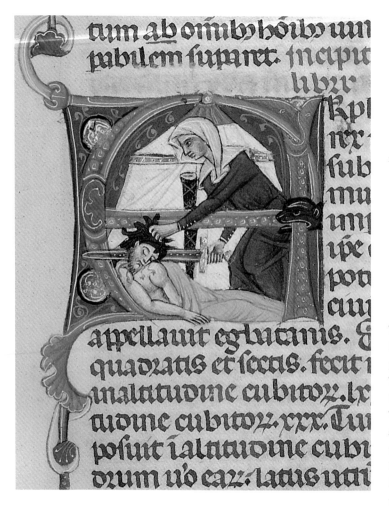

14 Initial *A*: Judith Beheading Holofernes
Artist Unknown
Bible
Bologna, about 1280–90
JPGM, Ms. Ludwig I 11 (83.MA.60),
fol. 217

One of the most famous stories from
the Hebrew Bible tells of the widow
Judith and the demise of the Assyrian
general Holofernes by her hand. Hoping
to save her homeland of Bethulia from
the encroaching Assyrian troops, Judith

seduces Holofernes at a banquet, and
once he is drunk and asleep in his tent,
she beheads him. In this compact initial,
Judith reaches over the crossbar of the let-
ter *A* to slay the sleeping Holofernes with
his own sword, the scabbard for which
still hangs from the roof of his tent. To the
medieval reader, Judith represented fidelity
and courage, and she was also a model for
widows, who were often marginalized in
medieval society without the protection
and financial support of their husbands.

15 Jael Slaying Sisera
(Judith Slaying Holofernes)
Follower of Hans Schilling from the
Workshop of Diebold Lauber
Rudolf von Ems, *Barlaam and Josaphat*
Hagenau, France (formerly Germany),
1469
JPGM, Ms. Ludwig XV 9 (83.MR.179),
fol. 61v

The text at the top of this page and the
image below conflate the stories of two
powerful biblical women, Jael and Judith.
The passage describes how Judith slays
Holofernes "with a nail through his head."
This detail appears in a different biblical
story of female bravery, in which Jael kills
the Canaanite general, Sisera, to save the
Israelites by driving a tent stake through
his temple while he sleeps. The theme of a
woman duping a celebrated military leader
with her feminine wiles likely led to the
medieval scribe and artist's combination
of these two role models who avenged the
Israelites.

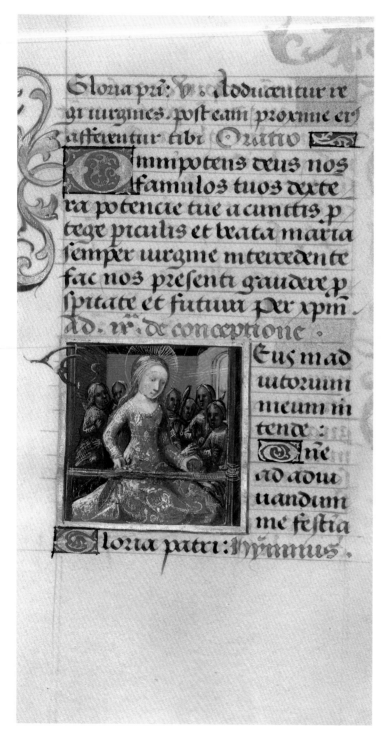

16 Mary Weaving
 Master of Cardinal Bourbon
 Poncher Hours
 Paris, about 1500
 JPGM, Ms. 109 (2011.40), fol. 121

17 The Annunciation
 Master of the Llangattock Hours and
 Willem Vrelant
 Llangattock Hours
 Ghent and Bruges, 1450s
 JPGM, Ms. Ludwig IX 7 (83.ML.103),
 fol. 53v

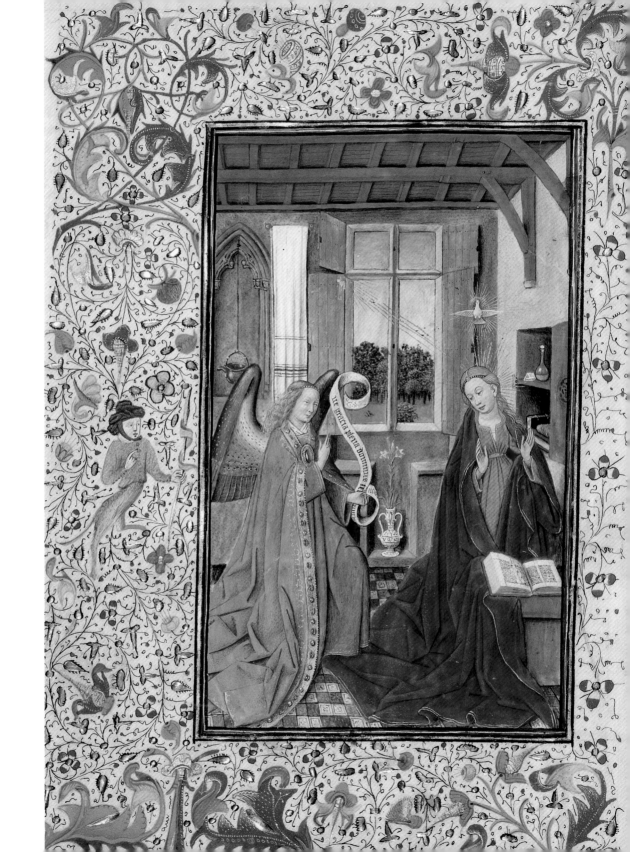

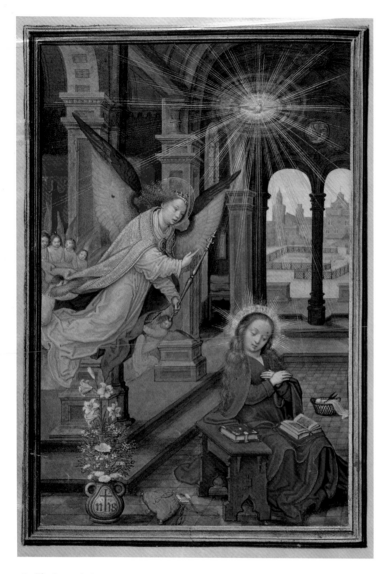

18 The Annunciation
Simon Bening
Prayer Book of Cardinal Albrecht of
Brandenburg
Bruges, about 1525–30
JPGM, Ms. Ludwig IX 19 (83.ML.115),
fol. 13v

19 The Coronation of the Virgin
Jean Bourdichon
Katherine Hours
Tours, about 1480–85
JPGM, Ms. 6 (84.ML.746), fol. 72

Like the Christian Old Testament, the
New Testament contains various female
figures who were prescribed as role mod-
els for medieval believers. Foremost in
importance was Mary, the mother of Jesus;
manuscript imagery celebrated every phase
of her life. In her early years before her
betrothal to Joseph, apocryphal sources
state that Mary was raised in the Temple
and was charged with the great respon-
sibility of weaving the curtains for its
sanctuary. She is sometimes pictured spin-
ning thread with a distaff and spindle or
weaving (fig. 16), both of which were tasks
considered appropriate for young women
at all levels of society in the Middle Ages.

The Virgin was most honored for
her role as Christ's mother. Scenes of
the Annunciation, when the archangel
Gabriel delivered her the message that she
would give birth to Christ, abound. Two
late medieval manuscript images place
this event in a setting that would have
been familiar to a wealthy book owner
of the time. First is the rendition from
the Llangattock Hours (fig. 17), which
casts the event in a northern European
domestic interior with all the trappings of

a well-to-do household. About a hundred years later, Simon Bening rendered the same scene in an Italian Renaissance–style church interior, with Mary's sewing basket pictured close by (fig. 18). In each of these two instances, Mary is shown interrupted while reading her prayer book, and her gesture signals her acceptance of God's will. Through these images, Christian women were encouraged to model themselves after her piety and unquestioning devotion to God.

As a result of her exemplary life free from sin, Mary received her final reward upon her death by being assumed bodily into glory and crowned Queen of Heaven. In this image from the Katherine Hours, as God blesses the Virgin from above, two angels lower a crown onto her head (fig. 19). The illumination accompanies the Hours of the Virgin, a set of prayers devoted to Mary that was a common feature in medieval books of hours. The intertwined initials *I* and *K* that appear scattered throughout the margins of this page likely refer to the book's original owners, perhaps a woman named Katherine and her husband. Wealthy women were important manuscript patrons, as will be discussed further in chapter 4, and they were instrumental in the great popularity of books of hours in the Middle Ages.

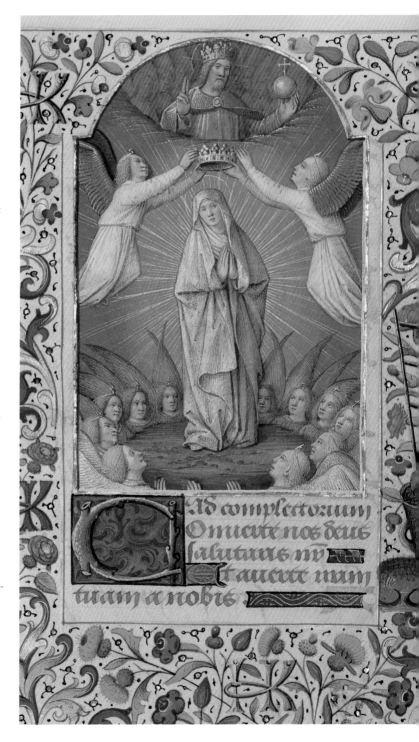

20 Initial *S*: Virgin and Child with
 Confraternity Members
 Artist Unknown
 Leaf from a choir book
 Siena, late thirteenth century
 T. Robert and Katherine States Burke
 Collection
 ———

As the key role model for medieval
Christians, especially women, the Virgin
Mary became the subject of veneration,
meditation, and song. In the lower half
of this choir book initial, male and
female members of a lay confraternity
process together toward a set of stairs,
perhaps indicating a church entrance.
Above, the half-length Virgin and

Child extend their hands over the group,
suggesting a holy icon that has become
animated as a result of the confraternity's
piety. This image represents an unusual
visual record of medieval Christians
directly following the biblical models that
were laid out for them, while also pro-
viding an example of pious behavior for
the reader.

21 The Virgin and Child with the
 Archangels Michael and Gabriel
 Artist Unknown
 Gospel book
 Ethiopia, about 1504–5
 JPGM, Ms. 102 (2008.15), fol. 19v

As in the Western Christian Church, the
Virgin Mary was of central importance
in the Ethiopian Orthodox Church,
which was founded in the fourth century.
This image of Mary holding the Christ
child, flanked by the protective archan-
gels Michael and Gabriel, is frequently
featured in Ethiopian wall paintings and
icons. Medieval liturgical manuscripts
from across Europe and the Mediterranean
often contained protective textile curtains
over full-page illuminations. The fact that
this is the only page in the manuscript
that received such a treatment indicates
the special status of this image of the Vir-
gin for the readers. Italian artists traveled
to the Ethiopian courts with images of
the Virgin and Child, and Ethiopian icon
painters adopted some of these European
artists' compositional conventions for
depicting this subject matter.

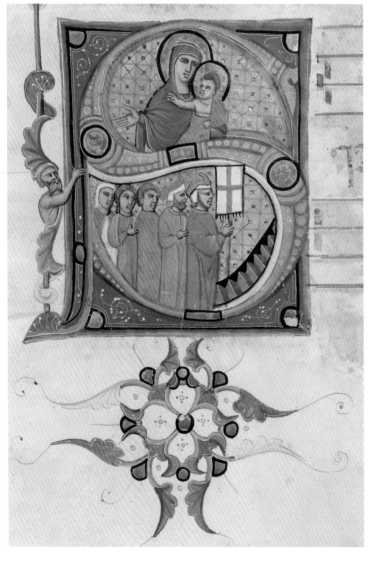

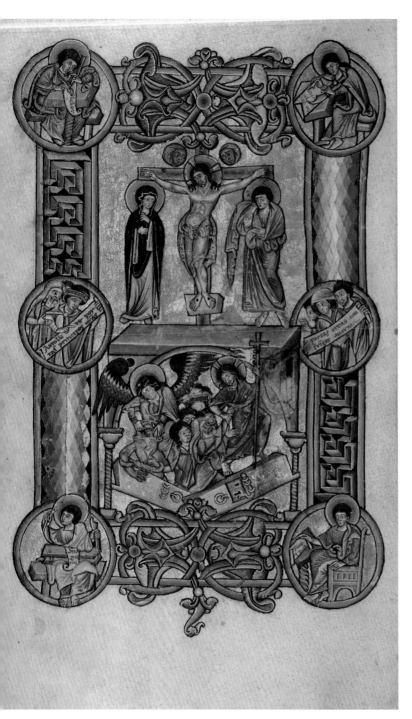

22 The Crucifixion and the
Harrowing of Hell
Artist Unknown
New Testament
Sicily, late twelfth century
JPGM, Ms. Ludwig I 5 (83.MA.54),
fol. 191v

This miniature displays an unusual com-
bination of images: below, Christ breaks
down the gates to Hell and extracts Eve
and Adam, rescuing them from certain
damnation resulting from their forbidden
consumption of the fruit from the Tree
of Knowledge. Above is a scene of the
Crucifixion, with the Virgin Mary and
John the Evangelist flanking Christ on
the cross. In medieval theology, Mary was
referred to as the New Eve, who followed
God's will by bearing Christ and living
without sin. Here, her presence above
Eve suggests her redemption of the sins
of humankind set in motion by Eve's
indiscretion.

23 Saint Barbara

Willem Vrelant

Arenberg Hours

Bruges, early 1460s

JPGM, Ms. Ludwig IX 8 (83.ML.104),

fol. 55

Saint Barbara was locked in a tower by her
father to shield her from the prying eyes
of suitors. He eventually builds her a bath-
house as a sanctuary, which is shown at
left. She becomes a Christian and refuses
a marriage proposal that came through
her father in favor of devoting her life
to God. Barbara uses her new abode as a
retreat for prayer until her furious father
brings her before a judge, who condemns
her to death. Frequently featured in books
of hours, Barbara stands between her
hermitage and her tower in this image,
surrounded by books as evidence of her
prayerful reading and as a model for the
owner of this manuscript, who used it for
his or her own prayers.

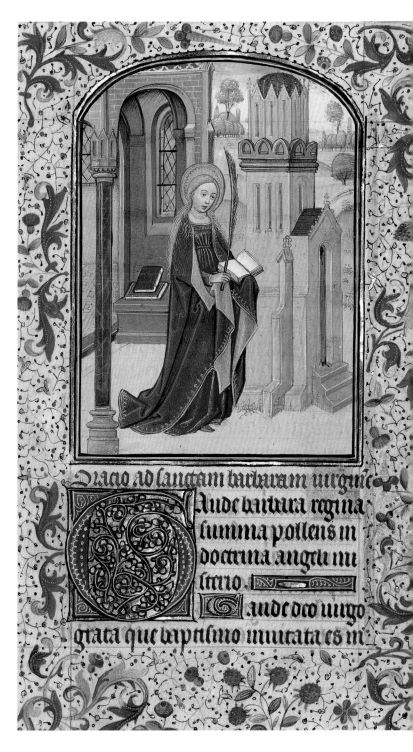

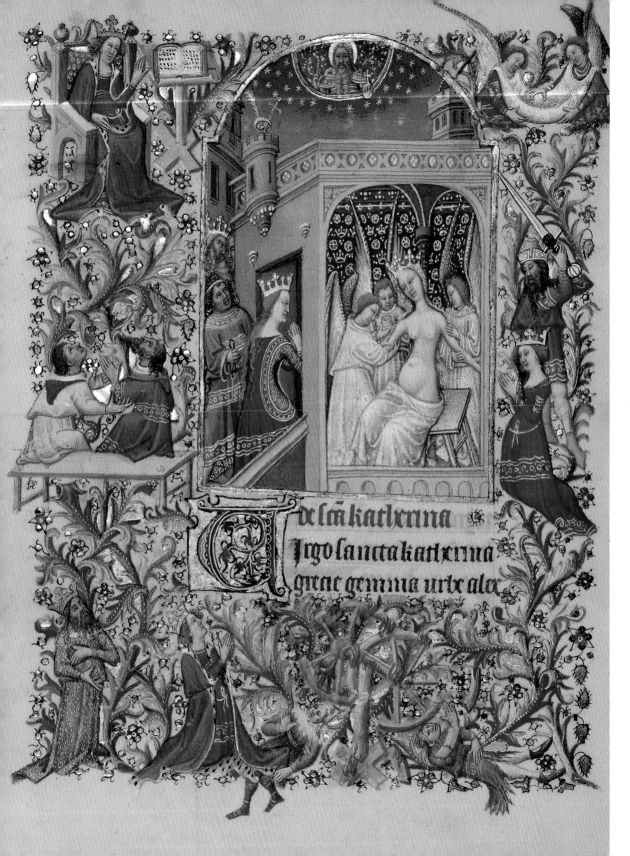

de sca katherina

rgo sancta katherina
grac gemma urbe alc

24 Saint Catherine Tended by Angels
Spitz Master
Book of hours
Paris, about 1420
JPGM, Ms. 57 (94.ML.26), fol. 45v

25 Initial _G_: Saint Catherine
Master of the Dresden Prayer Book
or Workshop
Crohin-La Fontaine Hours
Bruges, about 1480–85?
JPGM, Ms. 23 (86.ML.606), fol. 205v

Catherine of Alexandria was a learned
woman who refused to worship pagan
idols and confronted the Emperor Max-
entius about his persecution of Christians.
In some accounts, she also rebuffed the
emperor's marriage proposal, stating that
she was mystically married to Christ. The
refusal to follow the matrimonial path
expected of women at the time is a com-
mon theme in female saints' lives, whose
subversion often led to their demise. In
the left margin of the Spitz book of hours
(fig. 24), at the emperor's order, scholars
debate Catherine on the subject of pagan
gods. Gesturing to a book, she convinces
them of her argument, and some convert
to Christianity. At center, she is impris-
oned by Maxentius and attended to by
angels. The emperor's wife visits her cell,
and she too is converted after witnessing
the holy retinue. Although Jacobus de
Voragine's _The Golden Legend_, an influen-
tial thirteenth-century text about the lives
of the saints, mentions nothing about
Catherine's attire, the Spitz Master depicts
her nude from the waist up, revealing her
voluptuous form. This presentation sug-
gests her vulnerability, as she appears in a
manner shameful for women, who were

expected to be modest. Below, Maxentius
orders that she be martyred by having
her tied to a spiked wheel, a punish-
ment that she survives after the wheel
miraculously collapses. Eventually, she is
beheaded (right).

The Crohin-La Fontaine Hours
presents a more abbreviated encapsulation
of Saint Catherine's life (fig. 25). She is
represented as an erudite woman with a
book in her lap, holding a palm branch
as a symbol of her martyrdom, and by
her side is the wheel on which she was
tortured. Shown in a position of power
atypical for a medieval woman, she
appears seated triumphantly atop Emperor
Maxentius, symbolizing her repeated
thwartings of his punishments.

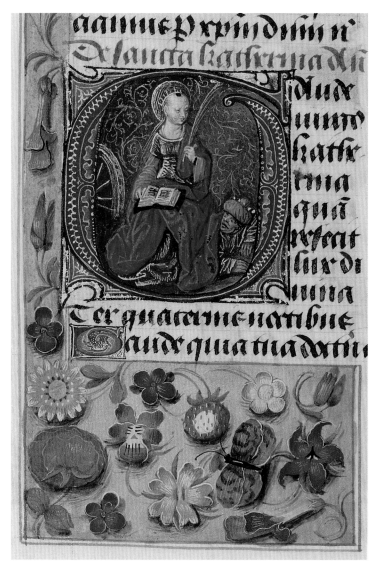

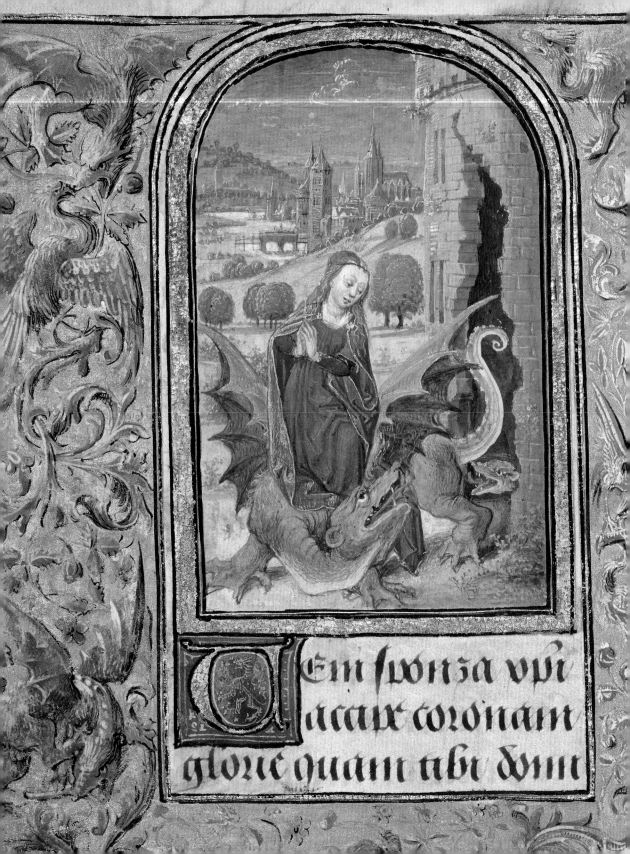

em sponsa vpi
cacix coronam
glorie quam tibi dum

26 Saint Margaret

Lieven van Lathem

Prayer Book of Charles the Bold

Ghent and Antwerp, 1469

JPGM, Ms. 37 (89.ML.35), fol. 49v

As the daughter of a pagan priest in
Antioch, Saint Margaret was imprisoned
by the Roman governor Olybrius and
endured many tortures for refusing to marry
him because of her Christian faith. Most
famously, she was devoured by a dragon
while at prayer, but managed to cut her way
out of the beast's belly with a small crucifix,
which is shown here floating above her
hands. Because she delivered herself safely
from harm, Margaret became the patron
saint of women in childbirth. Noblewomen,
in particular, were expected to conceive
children to continue the family line, but
giving birth was perilous and sometimes
fatal. Saints such as Margaret were thought
to assist in the process and thus were wildly
popular subjects in prayer books.

27 The Martyrdom of Saint Agatha

Artist Unknown

Picture Book of Madame Marie

Hainault, about 1285–90

Paris, Bibliothèque nationale de France,

Ms. n.a.fr. 16251, fol. 97v

Saint Agatha was a Sicilian woman who
refused the marriage proposal of the local
prefect, Quintian, in favor of pursuing a
religious life. As punishment, he had her
tortured by having her breasts removed with
pincers. Like the unusual image of Saint
Catherine by the Spitz Master (see fig. 24),
pictures of Saint Agatha typically show her
torso stripped bare, creating a scene that
was horrifying yet also titillating for a male

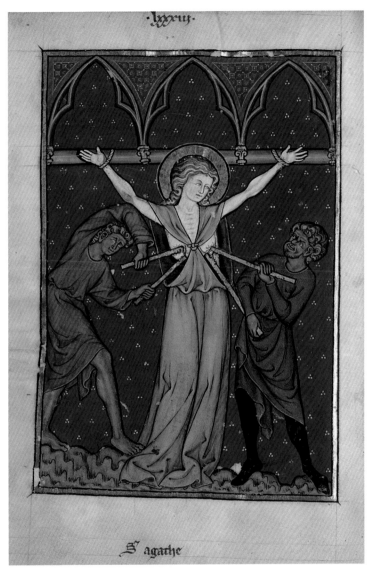

reader. This manuscript, however, was
commissioned by a laywoman, "Madame
Marie," who is mentioned in the list of
illustrations at the beginning of the book.
She was likely Marie de Rethel, a man-
uscript patron who, like other wealthy
female bibliophiles, also commissioned
a text from Latin into the vernacular.

The *Picture Book of Madame Marie* is
composed entirely of images from the
lives of Christ and the saints, without any
accompanying text. This continuous set
of devotional miniatures was the type that
Franciscans recommended for laypeople
throughout Europe, because it encouraged
focused meditation on saintly models.

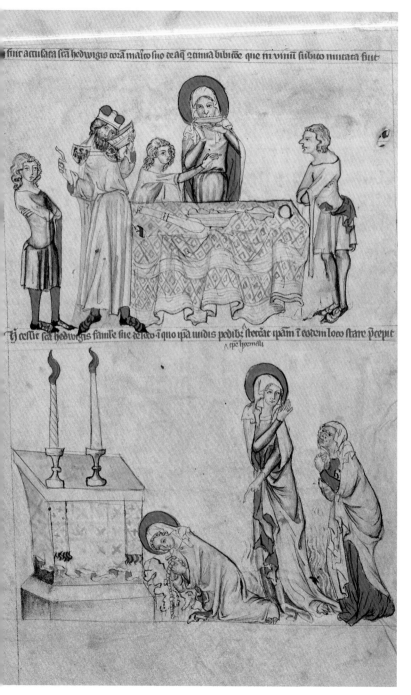

28 | 29

Saint Hedwig Refusing to Drink Wine;
Saint Hedwig Praying before an
Altar | Saint Hedwig and the New
Convent; Nuns from Bamberg Settling
at the New Convent
Artist Unknown
The Life of the Blessed Hedwig
Silesia, Poland, 1353
JPGM, Ms. Ludwig XI 7 (83.MN.126),
fols. 30v and 56

Created about one hundred years after
her death, this manuscript is the earliest
illuminated copy that survives of *The Life
of the Blessed Hedwig.* The text and images
trace the trajectory of her life and lineage
as a noblewoman, the miracles she per-
formed, her largesse as a patron who spon-
sored numerous religious houses, and her
taking of the Cistercian monastic habit
after her husband's death.

At the beginning of the manuscript is
a monumental, full-page portrait of Saint
Hedwig (see fig. 1). She holds symbols of
her religious devotion: a rosary, a statuette
of the Virgin and Child, and a prayer
book in which she marks her place with
her fingers. She stands with her boots
hung over her arm, since she chose to
walk barefoot like the apostles. At her feet
are the patrons of the manuscript, Duke

Ludwig I of Liegnitz and Brieg, who was a descendant of the saint, and his wife, Duchess Agnes. They kneel in homage, as if venerating a carved sculpture of the saint in a church niche, attesting to her enormous local importance in the region she ruled with her husband.

In her pursuit of a holy life, Hedwig abstained from wine, though her husband, Duke Henry, encouraged her to partake in order to cure her frequent illnesses. According to legend, when he tasted the contents of her glass one day, he discovered that the water that she had sipped had miraculously become wine (fig. 28), which would have recalled for the medieval reader Christ's transformation of water into wine at the Marriage at Cana and proved Hedwig's sanctity.

Noting the lack of religious foundations for women in Silesia, Hedwig founded a new convent in Trebnitz (fig. 29). In the upper register of this image, she directs the building project and presents it to her husband, who funded the venture. Below, she ushers a group of Cistercian nuns and their abbess toward their new convent. Like many other noble and royal women who were instrumental in establishing nunneries, Hedwig was buried at the convent upon her death.

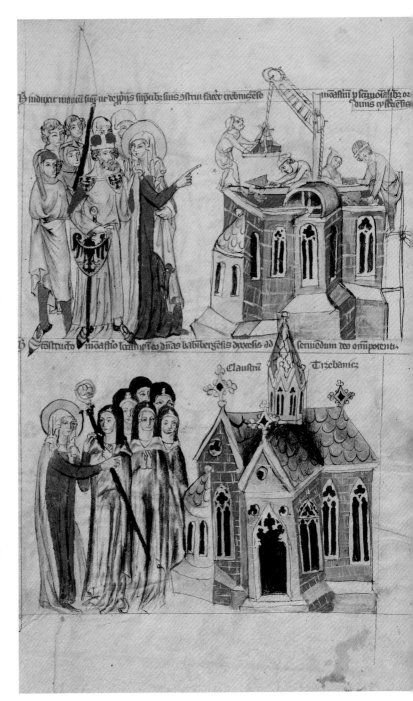

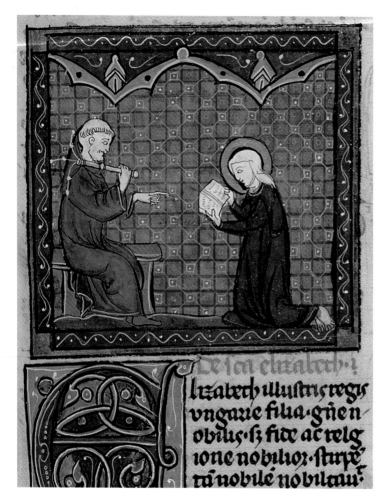

30 Saint Elizabeth of Hungary

Artist Unknown

Jacobus de Voragine, *The Golden Legend*

Perhaps Paris, end of the

thirteenth century

San Marino, The Huntington Library,

Ms. HM 3027, fol. 157

The generous and pious noblewoman Eliz-
abeth of Hungary was widowed at a young
age and chose to devote her life to God
instead of marrying again. Her Franciscan

spiritual advisor, Conrad of Marburg, was
a harsh man and subjected her to cruel
treatment, shown here as he prepares to
beat the kneeling, barefoot Elizabeth with
a cat-o'-nine-tails. This recalls the various
tortures that other female martyred saints
were forced to endure in pursuit of their
faith (see figs. 12, 23–27). Elizabeth was
the niece of Saint Hedwig and is depicted
as a young girl in Hedwig's lineage in the
earliest illuminated account of the elder
saint's life (see fig. 66).

31 Saint Joan of Arc

Jean Pichore

Antoine Dufour, *The Lives of*
Famous Women

Paris, about 1504–6

Nantes, Musée Thomas Dobrée,

Ms. 17, fol. 76v

Perhaps the most famous female saint
from the Middle Ages, Joan of Arc (1412–
1431) was a young Frenchwoman who,
upon receiving visions from Saint Cath-
erine (see figs. 24, 25, 83), Saint Margaret
(see fig. 26), and Saint Michael sought
to defend France against the occupying
English army. Unlike the many female
saints presented in attitudes of prayer,
Saint Joan of Arc was often depicted in
full armor heading into battle on a horse,
as shown here. By pursuing a historically
male vocation and cross-dressing as a man,
she broke with how medieval women
traditionally presented themselves. Joan of
Arc made a significant, positive impression
on the French people during her lifetime.
In 1429, two years before the saint died,
the celebrated female author Christine
de Pizan (1364–1430) (see fig. 93) wrote
Poem of Joan of Arc, her final work, which
celebrated the saint's bravery during her
own lifetime.

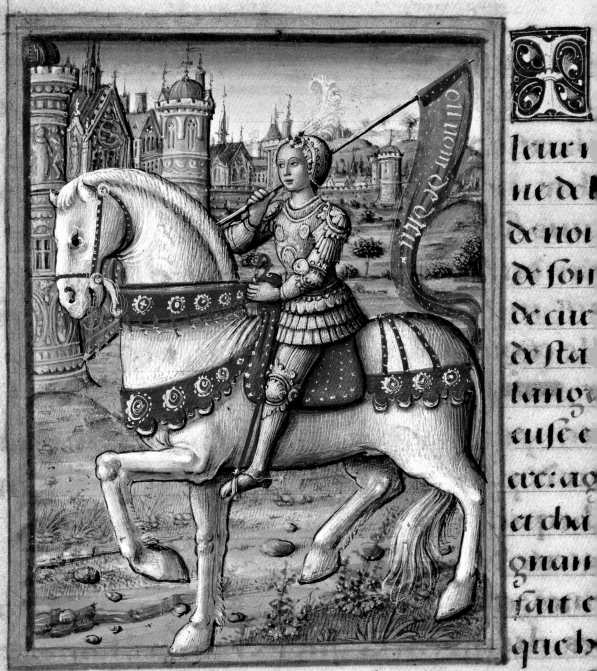

leur i
ne d l
de noi
de foi
de cue
de ſta
tango
euſe e
arc ag
et chi
gnan
fait e
que h

au fait de ſa vacation champeſtre: or ſi
et a to[us] honneſtes faitz ſe exercitoit, ta[n]t
en leage de xvi ans eut reuelacion du c

32 Initial _D_: A Woman Feeding a Leper in Bed

Artist Unknown

Psalter

Engelberg, about 1275–1300

JPGM, Ms. Ludwig VIII 3 (83.MK.94),

fol. 43

Victims of leprosy, a highly contagious disease, were forced to live in isolation from their communities in the Middle Ages. This nun's presentation of food to the afflicted man therefore demonstrates selflessness in feeding such an outcast of society and exposing oneself to the disease. The psalm text that begins on this page meditates on human suffering, and the inscription above her head states, "As you did it to one of the least of these my brethren, you did it to me" (Matthew 25:40). This manuscript was made in Engelberg, Switzerland, perhaps for use in a Dominican convent; the image presents model charitable behavior for the nuns. Nunneries of the mendicant (begging) orders, namely the Dominicans and Franciscans, increased in popularity in the later Middle Ages. This was especially true in Germanic regions, where half of the 150 Dominican nunneries in Europe were situated by the time this psalter was made.

33 Initial _S_: The Virgin and Three Dominican Nuns in Prayer

Jacobellus of Salerno

Gradual

Bologna, about 1270

JPGM, Ms. Ludwig VI 1 (83.MH.84),

fol. 46

The three Dominican nuns in the lower margin of this page all turn their prayerful attention toward the Virgin and Child in the initial above. This choir book was used at a Bolognese convent during the Mass for the Vigil of the Assumption of the Virgin Mary. The pious attitudes of the nuns in the border would have acted as a guide for the users of the manuscript as they celebrated the feast dedicated to Mary's final reward in heaven after her death. Bologna was the final resting place of Saint Dominic, and it became the foundation for some of the earliest male and female Dominican communities, which adopted the Virgin Mary as the focus of their devotion.

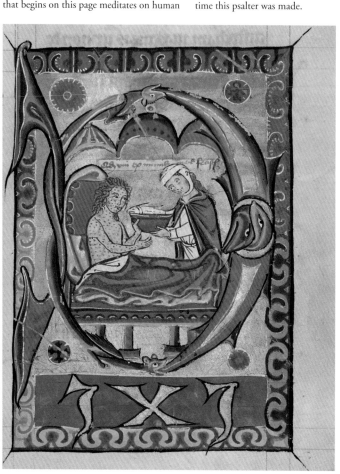

ster meus erit .

Sancti ypoliti soaozumqz euis offitium . Lu

sti epulentur. R. Justozum anime. Alleluya . V.

Sancti tui domine . off. Amma nia . co . dico aut .

nuugilia: asumptionis bate marie : offm .

al ue sancta pa

rens eni xa puerpera re

gem qui celum terram q

34 Men and Women Kneeling in Prayer

Willem Vrelant

Arenberg Hours

Bruges, early 1460s

JPGM, Ms. Ludwig IX 8 (83.ML.104),
fol. 82

———

In addition to biblical, saintly, and monastic ideals of proper conduct, laypeople were also depicted in prayer books as examples for the reader. Here, a wealthy man and woman kneel in prayer beneath God the Father flanked by angels. The subjects model pious behavior for the male and female members of their household,

who kneel behind each of them, respectively. This same couple is also presented in a similar fashion in a miniature of the Adoration of the Eucharist later in the same manuscript (see fig. 90), and they likely represent the husband and wife who owned this book.

35 Khusrau Spies Shirin Bathing

Artist Unknown

Nizami, folio from *Khamsa* (Quintet)
of Nizami

Shiraz, sixteenth century

New York, The Metropolitan Museum of Art, Gift of Richard Ettinghausen, 1975.192.15

———

This miniature illustrates the beginning of the famous twelfth-century Persian story written by Nizami about the love affair between the Iranian king Khusrau and the Armenian princess Shirin. After hearing about Shirin's beauty, Khusrau travels to Armenia to find her. Here, Khusrau rides with his retinue through the countryside and comes upon Shirin while she bathes nude in a stream accompanied by her ladies-in-waiting. Eventually the two marry. This event parallels the story of David and Bathsheba (see figs. 42, 45); however, unlike Bathsheba, who was often disparaged in the Middle Ages as a wanton woman, Shirin was held up as a model of a faithful lover and wife for Muslim women.

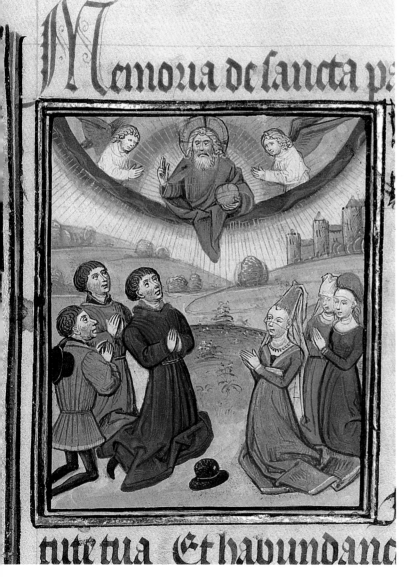

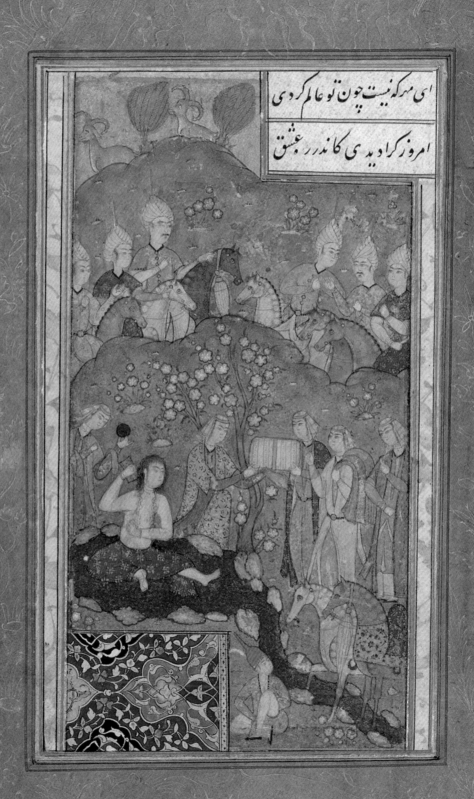

ای مهر که نیست چون تو عالم کردی

امروز کرا دیدهی کاندر بر عشق

36 Initial *K*: Caritas

Master of the Cypresses

Leaf from a gradual

Seville, about 1430–40

JPGM, Ms. 15 (85.MS.211), verso

———

The allegorical figure of Caritas (Charity)
is depicted here as a richly dressed woman,
her clothing indicating the abundance
that she has to give. She holds a crucifix
in her right hand and gives a gold coin to
a beggar with her left. The fine lines that
link Christ's side wound, Caritas's heart,
and the beggar's staff express the idea that
Christ's death on the cross was the ulti-
mate act of charity on behalf of human-
kind. The scroll above her head proclaims,
"Whoever has me covers a multitude of
sins," which both encourages the reader to
practice charity and promises rewards for
the giver.

37 Wisdom

Artist Unknown

Stammheim Missal

Hildesheim, possibly 1170s

JPGM, Ms. 64 (97.MG.21), fol. 11

———

This theologically complex image features
at its center the prominent figure of Wis-
dom in the guise of a woman dressed in a
splendid white, gold, and silver robe. She
supports Christ the Creator above, and she
is surrounded by Old and New Testament

patriarchs, reflecting Christ's lineage. This
miniature is part of a series of three images
in the manuscript that show the Creation
of the World, then this personification of
Wisdom, and finally the Annunciation, in
which the archangel Gabriel delivers his
message to the Virgin within the House of

Wisdom. The sequence therefore traces a
female lineage from Eve to Mary, wherein
the sins of Eve are rectified through the
presence of Wisdom and the Virgin's bear-
ing of Jesus.

38 Initial *O*: A Prophet Instructing a
Woman with a Mirror
Artist Unknown
Marquette Bible
Possibly Lille, about 1270
JPGM, Ms. Ludwig I 8 (83.MA.57),
vol. 3, fol. 234

———

The beginning of the book of Ecclesi-
asticus, which this illuminated letter
introduces, talks about the great virtue of
Wisdom and refers to it using the femi-
nine pronoun. In this text, and elsewhere
in medieval theology, wisdom is closely
associated with the virtue of Prudence,

whose attribute is a mirror. This image of
a woman holding a mirror may also reflect
the counterpoint to wisdom—folly—
referenced in Ecclesiasticus 34:3: "What
you see in a dream is no more real than
the reflection of your face in a mirror."
Mirrors backed with luxurious carved
ivory cases were frequently found among
wealthy women's toilet items and were
sometimes received as gifts from suitors.
The woman depicted here with a common
medieval household item is therefore
simultaneously a reminder of both the
virtue of Wisdom and the vice of Pride.

39 Female Personifications of Hatred,
Evil, Vileness, and Greed
Artist Unknown
Guillaume de Lorris and Jean de Meun,
Romance of the Rose
Paris, about 1405
JPGM, Ms. Ludwig XV 7 (83.MR.177),
fol. 2

———

The popular medieval story *Romance
of the Rose* tells the tale of a lover who
becomes smitten with a rose, a symbol of
his beloved, held captive in a castle. In his
quest to liberate his love, he encounters
numerous personifications of virtues and
vices, all in the guise of women, who
either help or hinder him in his quest.
At the beginning of the text, the man
comes upon the Garden of Love, which
is surrounded by walls decorated with
sculptures of women. This page depicts
the first four—Hatred, Evil, Vileness, and
Greed—illustrating the fact that in the
Middle Ages, female figures were used to
express both positive and negative attri-
butes of humankind.

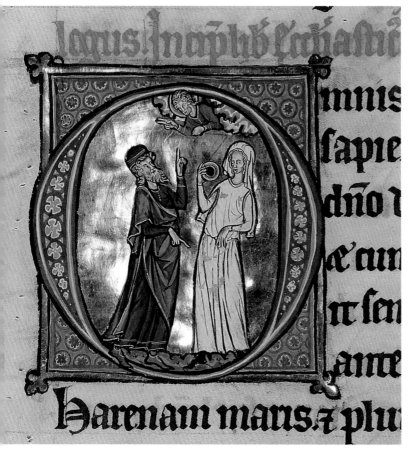

Les ymages et les paintures
Du mur uoulentiers remiray
Si uous conteray et diray
De ces ymages la semblance
Si com moy uient en remenbrance
Dame .j.

A senestre auoit de les lui
Son nom dessus sa teste lui
Appeller estoit felonnie Uilenie .iij.

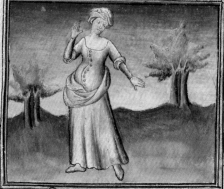

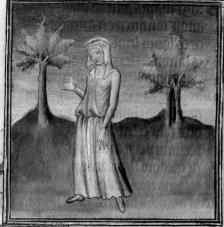

Ens ou millieu ie ui hayne
Qui de courroux et datayne
Sembla bien estre esmouuerresse
Et uenimeuse et tancerresse
Et plaine de grant cuuertage
Estoit par semblant cel ymage
Si nestoit pas bien atournee
Ains sembloit estre forcenee
Rechignie auoit et froncie
Le uis et le neis secourtie
Lcidement iert appareilliee
Car elle estoit entourtilliee
Hideusement dune touaille
Felonnie .ij.

Une ymage qui uilenie
Auoit nom rien deuers destre
Et estoit auques de tel estre
Com ces deur et dautel faiture
Bien sembloit male creature
Et despiteuse et outrageuse
Et mesdisant et ramponneuse
Moult scot bien faire et bien pourtrare
Cilz qui cel ymage scot faire
Car bien sembloit estre uillaine
De douleur et de despit plaine
Et femme qui prut seust
Donnourer ce quelle deust
Couuoitise .iiij.

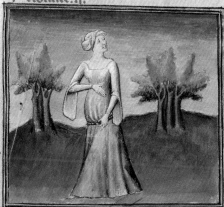

Une autre ymage dautel taille

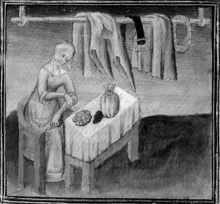

Pres fu painte couuoitise
Cest celle qui les gens atise

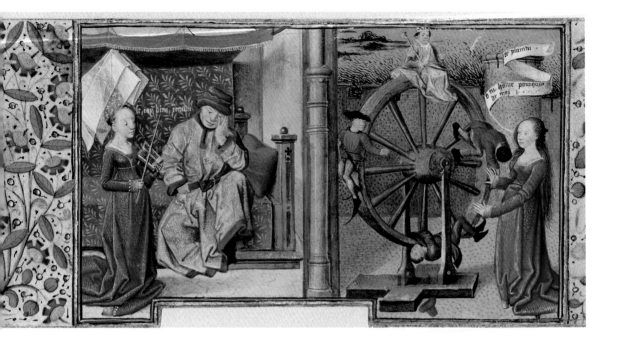

40 | 41

**Philosophy Consoling Boethius
and Fortune Turning the Wheel |
Philosophy Presenting the Seven
Liberal Arts to Boethius**
Coëtivy Master (Henri de Vulcop?)
Boethius, *Consolation of Philosophy*
Paris, about 1460–70
JPGM, Ms. 42 (91.MS.11),
leaves 1v and 2v

These two manuscript miniatures origi-
nally accompanied a book written by the
early medieval author Boethius while he
was in prison, accused of plotting to over-
throw King Theodoric the Great. The text
consists of the writer's conversation with
Philosophy, depicted here as a woman
dressed in fashionable clothes of the fif-
teenth century. Philosophy shows him the
changeable character of Fortune, cast as
a woman who turns a wheel and changes
men's fate with the simple touch of her
hand (fig. 40). In a second image, Philoso-
phy presents to him the Seven Liberal arts
taught during the Middle Ages: Gram-
mar, Rhetoric, Logic, Music, Geometry,

Arithmetic, and Astronomy, which, like
the Seven Virtues, are shown here in the
guise of noblewomen, holding attributes
that identify them (fig. 41). In contrast to
this image of erudite ladies, many medie-
val male writers in reality opposed wom-
en's education, and women were barred
from the universities that had begun to be
founded around the year 1200 in Europe.
There was some support for teaching
women to read, namely so that they could
pray from their psalters or books of hours.
Saints Agatha, Agnes, Cecilia, Lucy, and
Catherine (see fig. 12) were invoked as
models of literate women whose prayerful
reading led to their redemption.

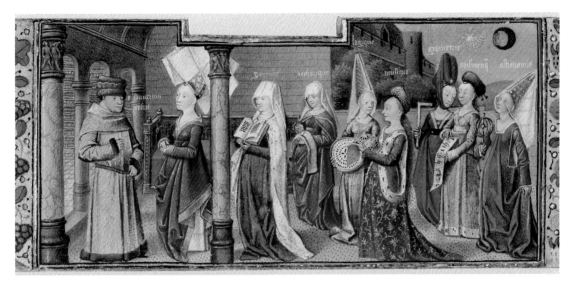

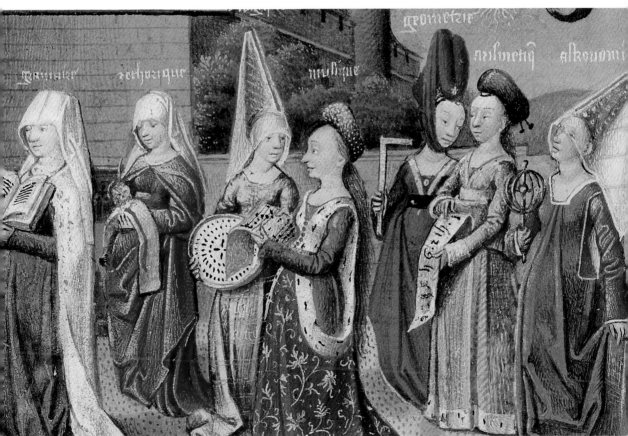

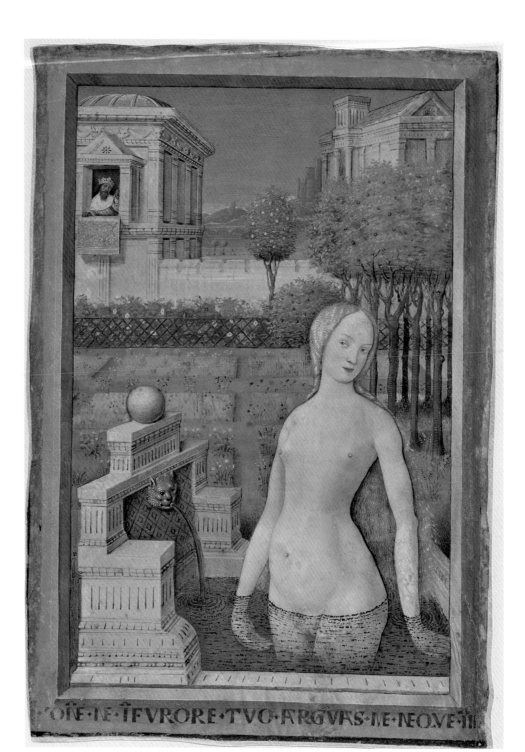

ONE ME INFVRORE TVO ARGVAS ME NEQVE III

CHAPTER TWO

WARNINGS TO MEDIEVAL WOMEN

ne woman who strayed from the recommended righteous path was Bath-
sheba, whose beauty tempted the well-respected King David to commit
adultery with her and hasten her husband's death. In Jean Bourdichon's
rendition of the scene, Bathsheba dominates the foreground of the com-
position, so much so that it is difficult for the viewer to avoid her nude
body and come-hither gaze (fig. 42). Her beautifully and minutely ren-
dered form reflects the late medieval ideals of feminine beauty, with her
rounded stomach and small, high breasts. As in many medieval images
of this story, Bourdichon's version seems to implicate Bathsheba and her
feminine wiles, rather than David, for the sin of adultery. This miniature
comes from a book of hours commissioned by King Louis XII and can
thus be read in multiple ways given its intended male viewer. The coquett-
ish and explicitly rendered Bathsheba must have been titillating for Louis,
a famous philanderer. At the same time, however, it originally prefaced
the penitential psalms, composed by David, and it displays the act that
eventually led to his own repentance. Many of the images of virtuous and
errant women were likely intended for a male reader and a male gaze; thus
they often reveal as much about masculine attitudes toward women as
they do about the cautionary tales that were meant to instruct women.

Sometimes virtuous and wanton women were juxtaposed in the same
image to emphasize the distinction between good and bad behavior. The
Virgin Mary was sometimes placed alongside Eve to suggest that Christ's
sinless mother would redeem those Christians born with original sin after
the Fall of Adam and Eve (see figs. 3, 43, 44). The book of Revelation, with
its often abstract visions of the end of days, laid out the positive model

42 **Bathsheba Bathing**

Jean Bourdichon

Leaf from the Hours of Louis XII

Tours, 1498–99

JPGM, Ms. 79 (2003.105), recto

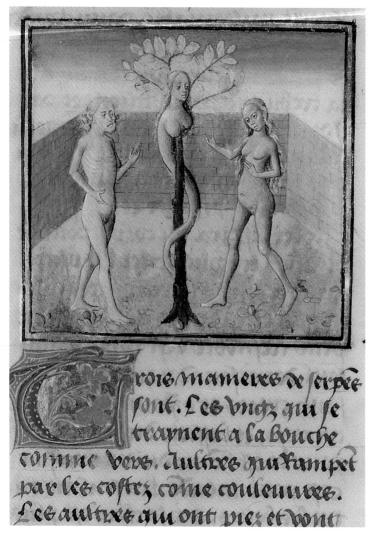

43 Adam and Eve with the Serpent
Artist Unknown
Vincent de Beauvais, *Mirror of History*
Ghent, about 1475
JPGM, Ms. Ludwig XIII 5 (83.MP.148),
vol. 1, fol. 36

Much like Mary was the ultimate positive
role model for medieval women, Eve
was the consummate warning to them.
Many medieval depictions of Adam and
Eve being tempted by the serpent to eat
from the Tree of Knowledge represent
the snake with a woman's face (see also
fig. 3). Medieval theologians implicated
Eve, because of her acceptance of the
forbidden fruit, for the fall of humankind.
Thus her feminine visage often appeared
on the head of the serpent, the other
party in the sinful act. In this rendition,
the artist strengthens the connection by
depicting the snake with an ample bosom,
undeniably gendering the animal and
mirroring Eve's nude form. Many medi-
eval depictions of Adam and Eve obscure
or omit their genitalia, but here the artist
includes these details and emphasizes the
couple's sexuality even before they became
knowledgeable of and embarrassed by
their nakedness.

of the Woman Clothed with the Sun—a symbol for Mary—in close
proximity to the Great Harlot (also called the Whore of Babylon) (see
figs. 51–53). Overall, more virtuous models were presented in the pages of
manuscripts than were wanton warnings, but both types of iconography
compelled the medieval reader to consider his or her own behavior, just as
these images enthrall the modern reader today with their directness and
dramatic presentation.

44 Initial *I*: Adam and Eve

Maestro Geometrico

Leaf from a choir book

Florence, about 1275

T. Robert and Katherine States Burke

Collection

———

The first letter *I* of the chant from this
Italian choir book leaf displays sev-
eral scenes from the book of Genesis.
Although the song text is drawn from the
first verses of the biblical book and there-
fore concerns God creating the earth and
its creatures, all the painted scenes relate
to Eve's sin and its tragic consequences.
At top, Eve gives Adam the fruit from the
Tree of Knowledge that she has accepted
from a serpent with a woman's face.
Below, Adam and Eve huddle together in
shame as God admonishes them for their
indiscretion. Finally, at bottom, an angel
of the Lord drives Adam and Eve out of
the Garden of Eden to fend for themselves
outside paradise. This narrative about
the fall of humankind at the hands of a
woman would have played out for the
choir as they sang from this page during
the first chant of the day on the second
Sunday before Lent.

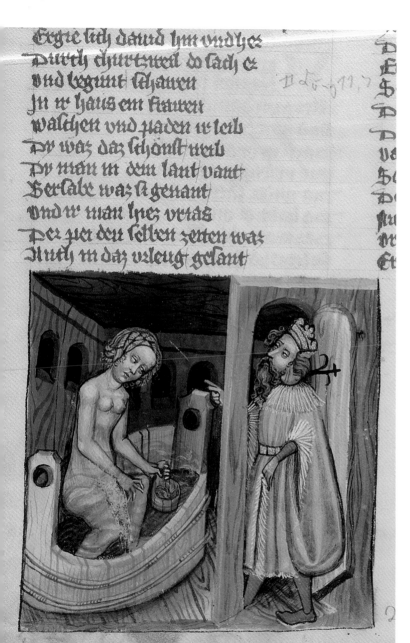

Ergie sich dauid hin vnd hes
Dürch churtzweil do sach er
vnd begunt schawen
In ir haus ein frawen
walthen vnd paden ir leib
Dy was daz schönst weib
Dy man in dem laut vant
Berlabe was si genant
vnd ir man hies vrias
Der zu den selben zeiten was
Auch in daz vrleug gesaut

45 David and Bathsheba

Artist Unknown

Rudolf von Ems, *World Chronicle*

Regensburg, about 1400–1410

JPGM, Ms. 33 (88.MP.70), fol. 191v

The Bible describes King David setting
eyes on the nude Bathsheba from the
roof of his house, thereby suggesting
the garden setting that characterizes
the many medieval images of this story. In
this German rendition, however, David
walks in on Bathsheba in an interior
setting, hidden from view in an enclosed
bathhouse. His invasion of her privacy
in this version seems to place the blame
on him for the indiscretions that follow.
In a relatively unusual turn for medie-
val imagery, the artist may have clearly
depicted Bathsheba's pudenda (as Bourdi-
chon did [see fig. 42]), since this portion
of the miniature was later scratched out.
The original patron of this manuscript
was female, and the subsequent owners
were a husband and wife, whose portraits
appear at the beginning of the manu-
script (see fig. 79). Perhaps the female
or male owner scratched out the image
because he or she sought to reduce its
erotic power, hoped to avoid the sin of
gazing upon Bathsheba's genitalia, or
even endeavored to preserve her modesty.

46 Hosea and Gomer

Master of Jean de Mandeville

Historical Bible

Paris, about 1360–70

JPGM, Ms. 1 (84.MA.40), vol. 2,

fol. 118v

———

According to the biblical book of
Hosea, the prophet of the same name
was told by divine prophecy to marry
a "wife of whoredom," and he selects
Gomer. After their union, she enters
into an adulterous relationship and
becomes her lover's slave, but Hosea
buys her back. Here they are shown
entering into an embrace of forgive-
ness. This moralizing tale would have
suggested to a medieval reader that
even sinful women like Gomer and
Mary Magdalene (see figs. 5, 6) could
redeem themselves.

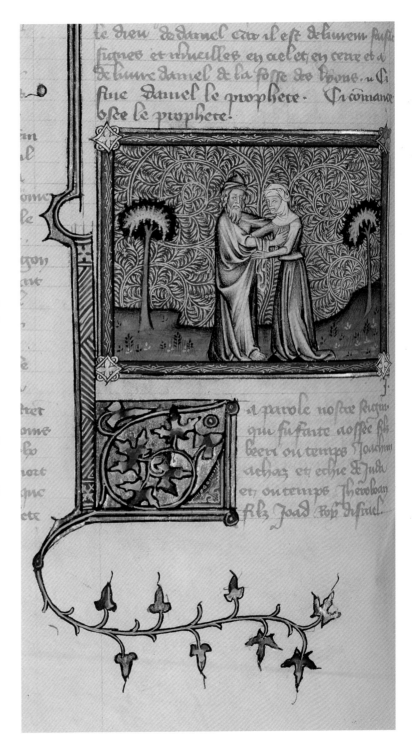

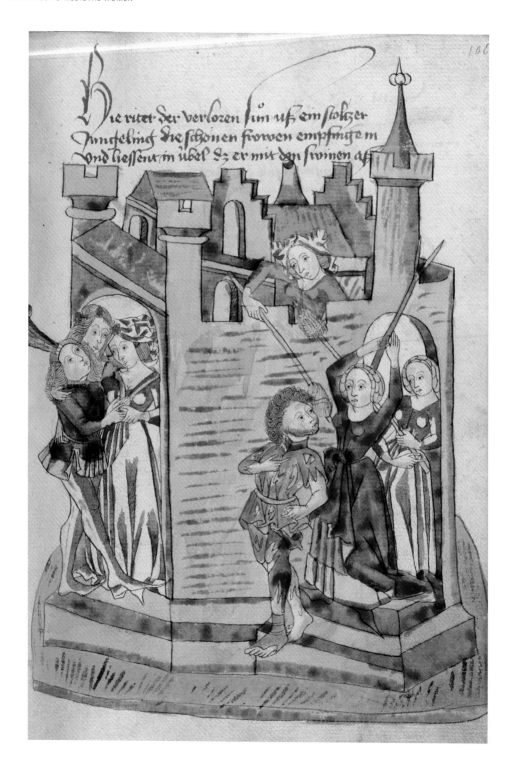

47 The Prodigal Son at the Brothel

Follower of Hans Schilling from the
Workshop of Diebold Lauber
Rudolf von Ems, *Barlaam and Josaphat*
Hagenau, France (formerly Germany),
1469
JPGM, Ms. Ludwig XV 9 (83.MR.179),
fol. 106

———

Wearing fine clothes, the Prodigal Son
is welcomed into the brothel at left, but
once he runs out of money—as indicated
by his tattered clothing—he is chased
out by the prostitutes, who beat him
with distaffs and a pitchfork. This image
offers insight into the medieval attitudes
toward prostitution, which in this case
is used as an amusing detail to represent
the biblical description of the Prodigal
Son's "riotous living" (Luke 15:13). The
practice of prostitution was disparaged but
generally accepted and even regulated in
many European cities. It was one of the
livelihoods available to poorer women,
along with the occupations of household
servant, market vendor, and laundress.
The image also reveals that certain pur-
suits, such as spinning wool (as suggested
by the brandished distaffs), were deemed
appropriate skills for women at every level
in society.

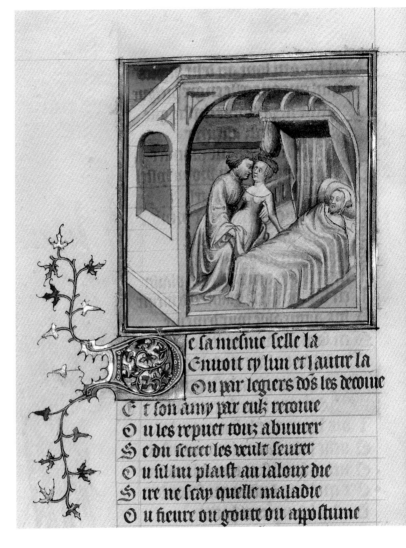

**48 A Woman Meeting with Her Lover
While Her Husband Sleeps**

Artist Unknown
Guillaume de Lorris and Jean de Meun,
Romance of the Rose
Paris, about 1405
JPGM, Ms. Ludwig XV 7 (83.MR.177),
fol. 91v

———

After drugging her husband, who sleeps
deeply in his bed at right, his wife is able
to meet with her lover, and they frolic lust-
ily to their hearts' content. This section of
the *Romance of the Rose* offers commentary
on the treachery of women. The authors
voice the tale through the personification
of Old Age, who instructs Fair Welcome
on the wiliness of women and how they
can bring harm to men. Although canon
law deemed that adulterous husbands and
wives should both be punished, in reality
men's indiscretions were often ignored,
while the women accused of infidelity
were harshly tried and reprimanded. This
image thus reflects both the great measures
that women took to avoid being caught in
adultery, as well as the medieval fear of the
power of women's sexuality.

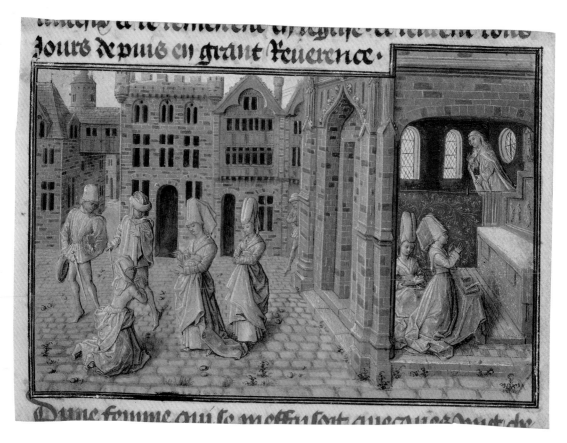

49 Miracle of the Adulterous
 Woman's Repentance
 Lieven van Lathem
 Miniature from Jean Miélot,
 The Miracles of Our Lady
 Ghent, about 1460
 JPGM, Ms. 103 (2009.41), recto
 ―――

At right in this image, which is skillfully rendered in grisaille (shades of gray), the wife of an adulterous knight entreats the Virgin Mary to punish her husband's lover. Christ's mother refuses, since the mistress is devoted to her. The wife and lover see each other on the street, at left, and the wife lets her know that she was spared by the Virgin. The adulteress asks for the wife's forgiveness and vows to end the affair. The moral expressed to women in this miniature is that while spiteful wishes are not rewarded, piety is, and as in the story of Hosea and Gomer (see fig. 46), if one repents, one will be shown mercy.

50 The Temperate and the Intemperate
Master of the Dresden Prayer Book
Miniature from Valerius Maximus,
*The Memorable Deeds and Sayings
of the Romans*
Bruges, about 1475–80
JPGM, Ms. 43 (91.MS.81), recto

Set before a luxurious textile hanging, the elegant banquet scene in the background features upper-class diners arranged formally in their proper places; at center, the woman looks demurely down at her hands, with one laid politely atop the table. In contrast, in the rowdy group in the foreground, lower-class peasants ply each other with drink, a drunken diner falls asleep, a woman cavorts with a man seated on the floor, and a female server crudely lifts her

dress, as if to use it as a towel to offer the diners. At left, Valerius Maximus, author of this text about ancient customs and heroes, gestures to the lower, disorderly scene to explain the merits of temperance to the Roman emperor Tiberius (ruled AD 14–37). This image conveys Valerius's moralizing message recast in a fifteenth-century setting, with different classes of women and their respective stereotypical behaviors juxtaposed.

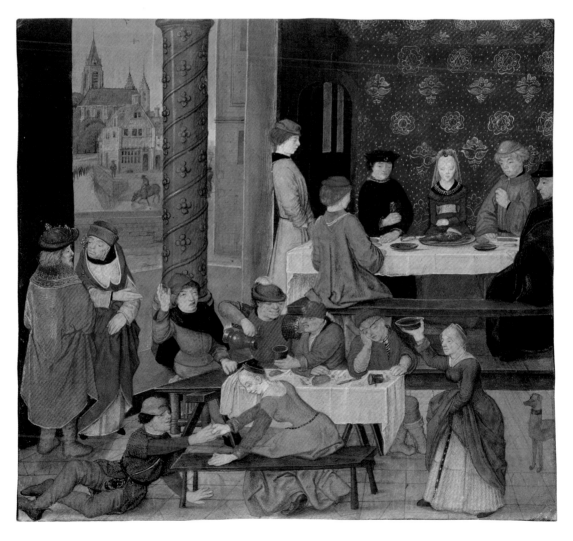

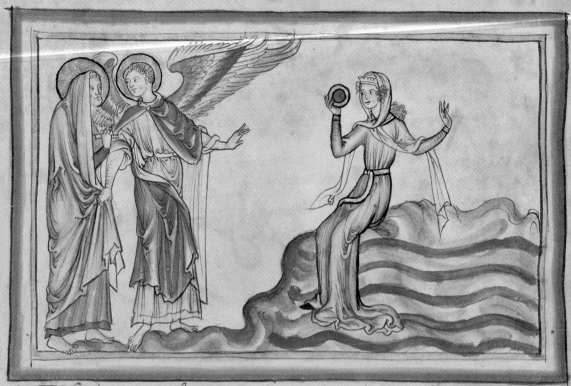

Et uenit unul de septem anglis
qui habebant uii phialas. et lo
cutus est mecum dicens. Veni
ostendam tibi dampnacionem
meretricis magne que sedet sup aquas mul
tal cum qua fornicati sunt omnes reges t
re t inebziati sunt qui inhitant terram.
de uino pstitutionis ei

Sicut supius sub centu tube septimi angli
dicu uidui breuit comphensis ad ea
que preiniserat reclut atqz scam eccam sub spe
mulieris que amicta erat sole t luna sub pedibz
ei eccam describen passiones qual a diabolo
ptulit t qs ab Angxpo i sine mundi passuui est
admerit ita t hic sub estusione phiale septimi
angli diem iudicii siimetam pstringens ad
ea que premisit reunis atqz sb spe mulieris
meretricis ciurtate diabolu destribe qual penas

p sceleribz suis pastura sit i sequentibz manifes
tat. angls si phialam huis predicatores suos
designat Johannes Aii typum tenet omnium
fideliu coherede ista i aliquibz locis ronia sub ii
que tunc eccam di plequebatur. in quibusdii i ge
uali cuitate diaboli. i dz omne corpus reprobox
demoustrat. angls qz Johanni ostend dampna
cione meretricis magne. p predicatores sancti z u
bis t scriptis fidelibz ostenditur qual penas i
pii p sceleribz suis pciantur ut eoz penis terri
a pctis abstineant. Que sup aquas mult sedere
dicitur. qz ex multitudine gentiu que p aquas
designatur cuitas diaboli constrituur. cum
q reges tre fornicati ee diicit qz scelera babilo
nis pocius auxerunt qin destruerunt. Et inebzi
ati sunt omnes qui inhabitant tram de uino
pstitutionis ei. uiuu pstiturois diuisi erro
res diuisa sunt scelera impie cuitatis

51 | 52 | 53

The Great Harlot of Babylon |
The Great Harlot on the Beast |
The Drunken Harlot

Artist Unknown

Getty Apocalypse

Possibly London, about 1255–60

JPGM, Ms. Ludwig III 1 (83.MC.72),

fols. 35v, 36, and 36v

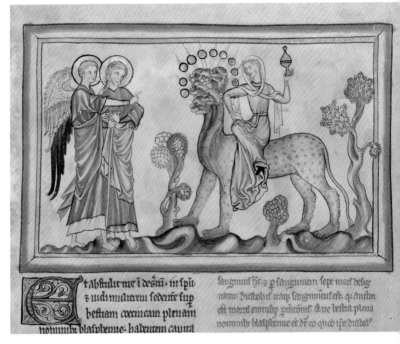

This sequence of three scenes from the book
of Revelation presents the character of the
Great Harlot, also known as the Whore of
Babylon. In the first image, one of the seven
angels of the Apocalypse introduces the
apostle John to the Harlot, who represents
the source of earthly abominations and may
have symbolized pagan Rome and its per-
secution of the Church (fig. 51). She vainly
admires herself in a mirror, much like the
woman at the beginning of Ecclesiasticus in
the Marquette Bible (see fig. 38). The angel
states, "Come hither, I will shew thee the
judgment of the great harlot that sitteth
upon many waters; with whom the kings of
the earth committed fornication, and they
that dwell in the earth were made drunken
with the wine of her fornication" (Revela-
tion 17:1–2). On the facing page, the Harlot
appears seated atop the incarnation of the
Devil, a beast with seven heads and ten horns
(fig. 52). In the final miniature, the Harlot
kicks up her heels and dances drunkenly
after consuming the blood of saints (fig. 53).
Her inappropriate behavior and immodest
attire (uncovered head and exposed knees)
would have marked her as a loose woman
for the medieval reader of this manuscript.
She would also have stood in stark contrast
to the exalted Woman Clothed in the Sun
described earlier in the book, who was associ-
ated with the Virgin Mary.

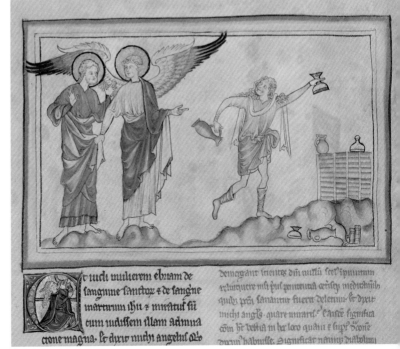

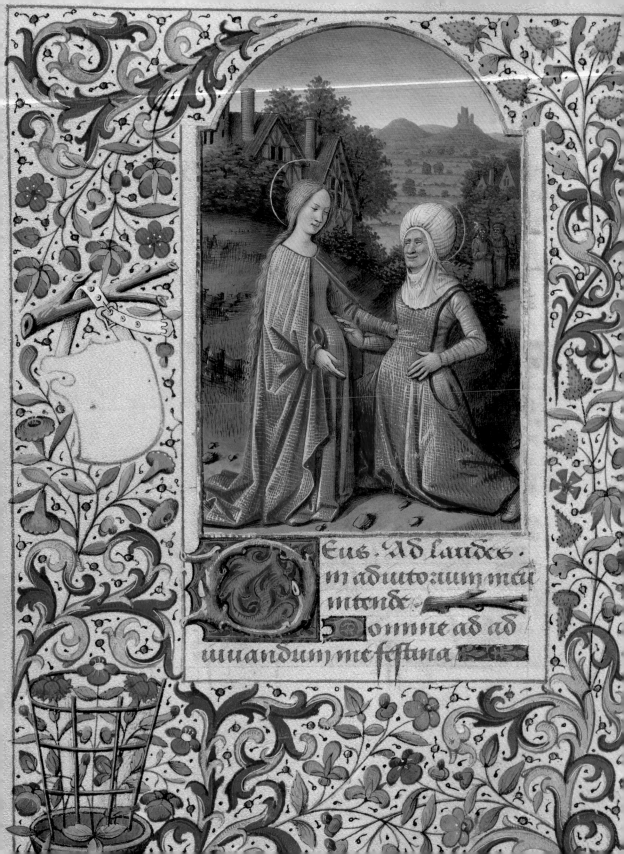

eus. Ad laudes
m adiutorium meu
intende
Domine ad ad
iuuandum me festina

CHAPTER THREE

MEDIEVAL WOMEN IN DAILY LIFE

hile pregnant with Jesus, Mary traveled to see her cousin Elizabeth, who was also miraculously pregnant in her old age with John the Baptist. This late fifteenth-century image from a French book of hours depicts the women greeting each other with warm smiles and an embrace, as Elizabeth intimately touches both her rounded abdomen and Mary's (fig. 54). The women mirror each other in figure and gesture, foreshadowing the close bond between Christ and John as they reached adulthood. The biblical story of the Visitation illustrates several of the key roles of women in daily medieval life, namely in relation to the family. Women were generally expected to marry and bear children, run the household, and raise its young members. The image also speaks of the network of relationships among related women, which further strengthened familial bonds and political ties between families.

Although their voices are sometimes difficult to hear, the constant visual presence of women in illuminated manuscripts attests to the fact that they participated actively in most aspects of medieval life. We learn about them especially in their interactions with men, who were primarily responsible for recording the history of the medieval world. Some of the most compelling stories told are of the courtly romances of men and women who intermingled and embarked on love affairs, often following but occasionally breaking strict rules of conduct. Relationships between lovers sometimes formed the foundation for marriages, but more often their betrothals were carefully crafted by their parents and arranged while they were still children. Medieval Christian marriages typically took place before the doors of a church, where the bride would receive a ring from

54 The Visitation
Jean Bourdichon
Katherine Hours
Tours, about 1480–85
JPGM, Ms. 6 (84.ML.746), fol. 41v

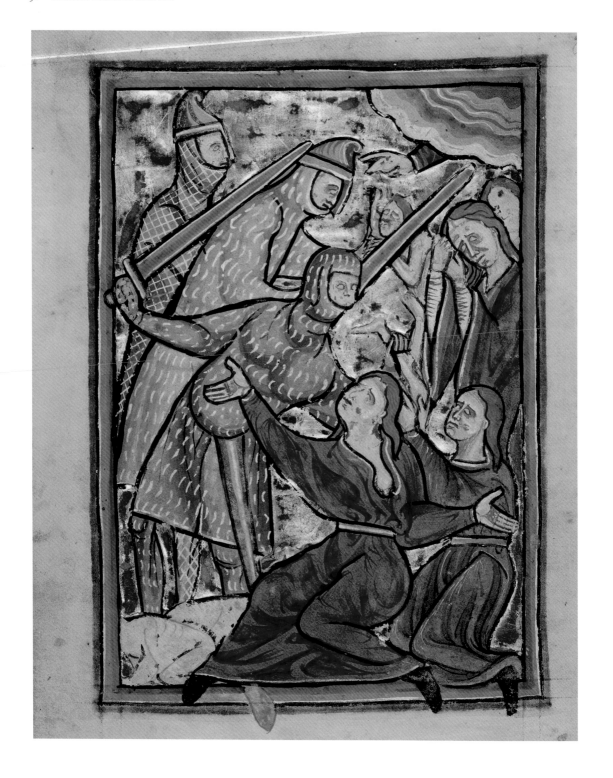

the bridegroom. Although many images of marriages depict priests offi-
ciating these ceremonies, the presence of a cleric was not required by the
church until the fifteenth century. Once married, wives headed up the
day-to-day functions of the household. In the ruling classes, wives also
performed an important political role as negotiators, and the very act of
marrying created links among the various courts across Europe, cement-
ing alliances and mending strained political and economic relationships.
In exceptional cases, medieval queens and empresses such as Eleanor of
Aquitaine and Mary of Burgundy ruled in their own right, either inherit-
ing lands from their fathers or reigning in place of their adolescent sons.

 Beyond the political and social ties established through marriages,
the primary purpose of wedded unions was the conception of children.
The establishment of a genealogical line was of crucial importance for
sustaining the status of aristocratic families and for creating bonds with
other families. Once children were born, women held the primary
responsibility for their care and upbringing. Evidence of the nature of
mothers' relationships with their children in the Middle Ages was often
expressed through images of the Virgin Mary and her son, Jesus. Man-
uscript illuminations depict her constant presence throughout Christ's
infancy, adolescence, adulthood, and death.

 A mother's love was communicated most profoundly upon the death
of her child. Biblical scenes of the Massacre of the Innocents and the
Pietà express the anguish and sorrow of mothers who have just watched
their children be slain before their eyes. In this image of the Massacre of
the Innocents from the *Vita Christi* manuscript from England (fig. 55),
soldiers wielding swords snatch infants as their mothers clutch desperately
at their babies' flailing limbs. In the foreground, one of the women faces
the viewer with her breast exposed, as if she were nursing her child when
the soldiers descended. Women also performed an important function as
mourners of the deceased. After Christ's death, the Gospels state that his
female followers visited his tomb in order to anoint his dead body with
spices (fig. 56). Medieval books of hours frequently featured prayers to be
said on behalf of the dead, accompanied by scenes of funerals taking place
within churches. One example shows nuns, monks, priests, and laypeople
gathered together around the draped bier, singing and praying during the
burial Mass (fig. 57).

In addition to being the anchor of the medieval family, women played a vital economic role. Peasant women helped harvest the fields alongside men, and women of the growing merchant class produced and sold crafts and participated in the trade of goods in city and country markets (figs. 9, 75). Wealthy women fueled the economy as well, especially in relation to the luxury goods that they commissioned for themselves and gave as gifts to family and in political negotiations.

56 The Women at the Tomb

Artist Unknown

Gospel book

Nicomedia or Nicaea, early–late

thirteenth century

JPGM, Ms. Ludwig II 5 (83.MB.69),

fol. 74v

57 Office of the Dead

Master of the Llangattock Hours

Llangattock Hours

Ghent and Bruges, 1450s

JPGM, Ms. Ludwig IX 7 (83.ML.103),

fol. 131v

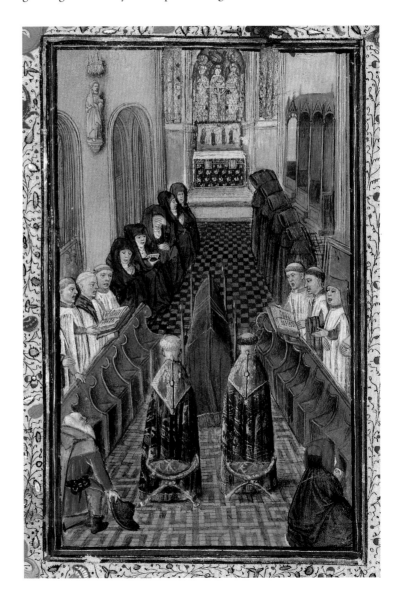

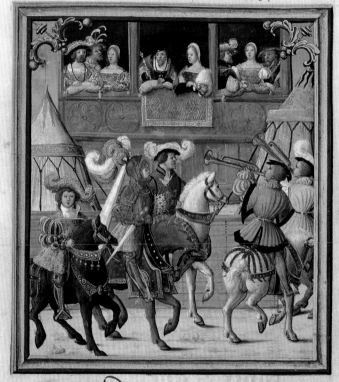

58 **Jacques de Lalaing Arriving at a Joust before the King of France**
Circle of Master of Charles V
Book of the Deeds of Jacques de Lalaing
Belgium, about 1530–40
JPGM, Ms. 114 (2016.7), fol. 40v,
Acquired in honor of Thomas Kren

In this image from the account of the life of the celebrated Burgundian knight Jacques de Lalaing, he visits the court of the king of France. Jacques catches the attention of two women, Marie d'Anjou and Marie de Cleves, and engages in flirtatious conversation with each one individually. When the time comes for him to participate in a joust at the king's tournament, each woman gives him a good luck charm—an embroidered kerchief and a jeweled armband—both of which he attaches to his armor. As the women observe the joust from the box above (at left and right), they realize to their dismay that Jacques has more than one lady love, and yet, following the accepted rules of courtly love, he did not compromise their honor. Flirtation was an integral part of medieval courtly love, but as female virginity was prized, this behavior was accepted within set limits so that a woman's eligibility to marry would not be compromised.

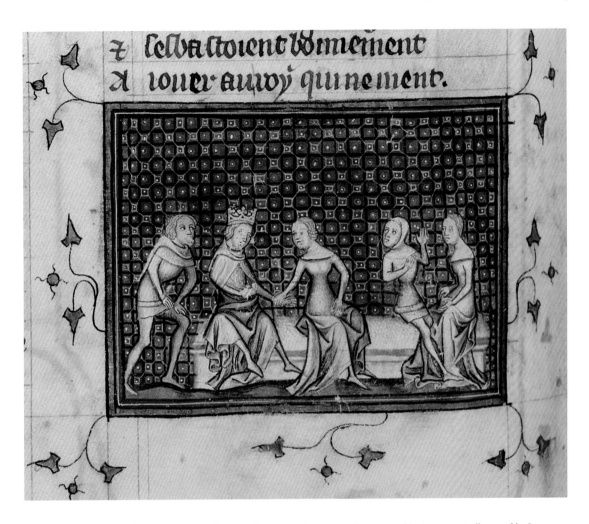

59 **Two Couples Playing a Game**

Assistant to the Master of the
Coronation of Charles VI (Hand 2)

Guillaume de Machaut, Collected Works
(The Ferrell-Vogüé Machaut)

Paris, about 1370–80

Ferrell Collection, Ms. Vg (Ferrell 1),
fol. 95v

———

Game playing was another means of
courtship and flirtation among lovers, as
shown by these two couples who flank a
king and play *Le roi qui ne ment* (The king
who does not lie). This image accompanies
a French vernacular ballad by the poet and
musician Guillaume de Machaut, who was
famed for his compositions about courtly
love. This manuscript copy of his work
was prized by female and male patrons

alike: it was originally owned by Jean,
Duke of Berry, who later gave it to Gaston
Phébus as a gift for negotiating Jean's mar-
riage to Jeanne de Boulogne. Jean's niece,
Violant of Bar, queen of Aragon, asked to
borrow it from Phébus and never returned
it. In the fifteenth century the book passed
to Maria of Castile, queen of Aragon, who
had it rebound and the binding marked
with her coat of arms.

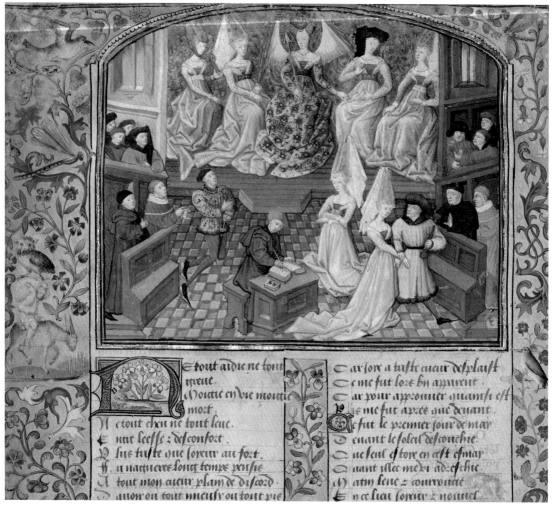

60 **The Beautiful Lady Condemned**
 by the Court of Love
Dunois Master
Achille Caulier, *The Cruel Lady in Love*
Paris, early fifteenth century
London, Christie's, May 25, 2016, lot 18,
fol. 122v

The celebrated French court poet Alain
Chartier composed his text *The Beau-
tiful Lady without Mercy* in 1424, and

numerous other medieval authors sub-
sequently responded to it in the form
of poetry, including Achille Caulier, the
author of the verses shown here. The story
unfolds as a dialogue between a lover and
his lady. In this miniature, after turning
down her suitor and thereby causing his
death, the lady receives her comeuppance
by being brought before the allegorical
Court of Love. The jury, composed of the
female personification Amour (Love), in

a gold robe covered with pansies, and her
cohort of ladies, condemns her to death.
The poem and its illustrations provide
insight into the customs of French courtly
love and male conceptions of and attitudes
toward women in this context. This luxury
copy of this text displays two initial *A*'s
linked together by a love knot in the lower
margins of this page, which likely refer to
the original owner of the manuscript.

61 Euryalus Sends His First Letter
to Lucretia
Artist Unknown
Eneas Silvius Piccolomini,
Story of Two Lovers
France, about 1460–70
JPGM, Ms. 68 (2001.45), fol. 30

This text, written by Eneas Silvius Pic-
colomini before he became Pope Pius II,
describes an affair between a member of
the Holy Roman emperor's court named
Euryalus and a married woman named
Lucretia. In the foreground, Euryalus gives
a love letter for Lucretia to a messenger,
Nisus. The narrative plays out across the
room, with Lucretia eventually receiving
the letter, tearing it to shreds, but then
reconsidering Euryalus's advances and
placing the fragments in a chest with her
jewels for safekeeping. Romances such
as this one were wildly popular among
the upper classes of French society in the
Middle Ages, and this miniature reveals
the power of letter writing to discreetly
negotiate and fuel love affairs at court.

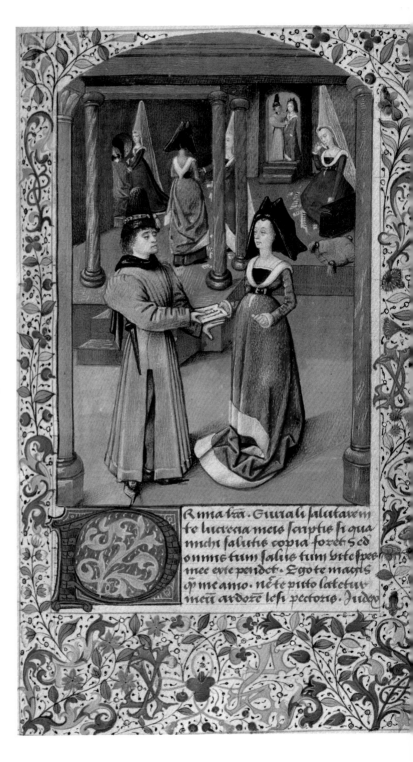

62 Abelard Embracing Heloise

Artist Unknown

Guillaume de Lorris and Jean de Meun,
Romance of the Rose

Paris, about 1405

JPGM, Ms. Ludwig XV 7 (83.MR.177),
fol. 56

Abelard and Heloise are one of the most
famous and romantic medieval couples.
Heloise d'Argenteuil was a learned young
woman known for her scholarship, and
Peter Abelard was a philosopher and
canon of Paris. Upon meeting Heloise,
Abelard begged her uncle to let him
become her teacher. Their intellectual
relationship eventually developed into an
illicit love affair, and Heloise gave birth
to a son out of wedlock. This miniature
depicts their forced marriage (right),
which prompted Heloise to flee to the ref-
uge of a convent. At left, she is shown in
her nun's habit, when their resulting corre-
spondence began. In one letter to Abelard,
she expressed ideas that were radical for
the time and contradicted Christian ideals
of marriage: "If the name of wife appears
more sacred and more valid, sweeter to me
is ever the word friend, or, if thou be not
ashamed, concubine."

63 **Initial *C*: Saint Nicholas**

Master of Gerona

Antiphonal

Bologna, late thirteenth century

JPGM, Ms. Ludwig VI 6 (83.MH.89),

fol. 171v

In this image, Saint Nicholas, a fourth-century bishop committed to helping the poor, drops gold coins through the window of the house of a man who could not provide dowries for his daughters, which would prevent them from marrying. In the Middle Ages, Saint Nicholas's cult spread throughout Europe and became especially popular in Italy, where his relics were relocated in 1087 and where this choir book was made. His charitable act also held great significance in Italy, where a dowry represented a woman's primary wealth and was strictly controlled by her husband's family. As dowries became increasingly expensive in medieval Europe, giving money to this cause became a common form of charity practiced by the wealthiest members of society on behalf of women of lower classes.

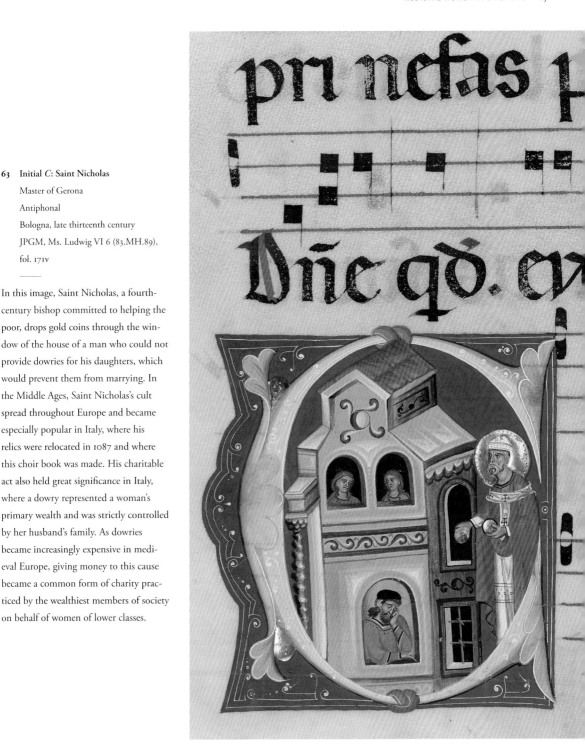

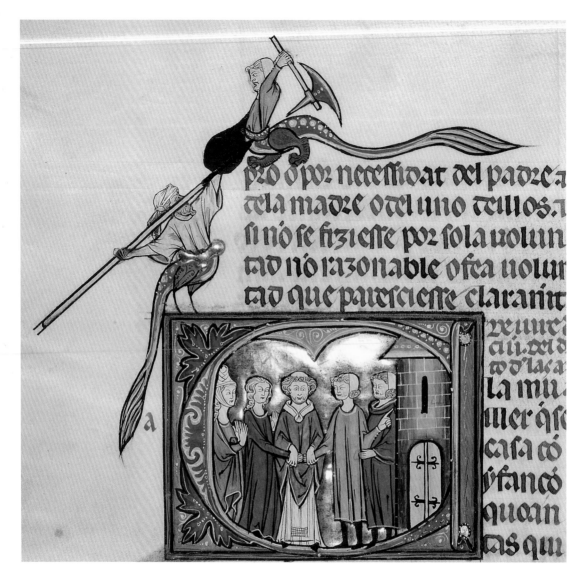

64 Initial *L*: A Marriage Ceremony

Artist Unknown

Vidal de Canellas, *Feudal Customs
of Aragon*

Northeastern Spain, about 1290–1310

JPGM, Ms. Ludwig XIV 6 (83.MQ.165),
fol. 197v

In this, the only surviving copy of the legal code of Aragon, the local laws regarding various social situations, including marriage, are laid out. Here, as a priest joins the hands of a man and woman in marriage, the husband points to his house, indicating that he is giving it to his wife as part of her dowry. The granting of dowries became complicated and costly during the Middle Ages, with the majority of the wealth provided by the wife's family, sometimes supplemented by the husband. It also became increasingly difficult for a woman to claim her husband's property after his death. Thus, law codes like this one provided crucial protections for a woman's rights in marriage.

65 The Marriage of Louis de Blois
and Marie de France
Master of the Getty Froissart
Jean Froissart, *Chronicles* (Book Three)
Bruges, about 1480–83
JPGM, Ms. Ludwig XIII 7 (83.MP.150),
fol. 288v

This courtly scene depicts Jean Froissart's account of the 1386 marriage between Louis de Blois and Marie de France, daughter of the Duke of Berry, who was the king of France's brother. The couple joins hands before a priest at the door of a church, with the male and female witnesses grouped almost exclusively by gender. The medieval marriage ceremony was not merely a joining of two people in matrimony but also created political and economic alliances that would be advantageous to the families involved. For example, such a bond was forged when Margaret of York married Charles the Bold (see figs. 78, 91), a union that solidified a key trade relationship between England and Burgundy.

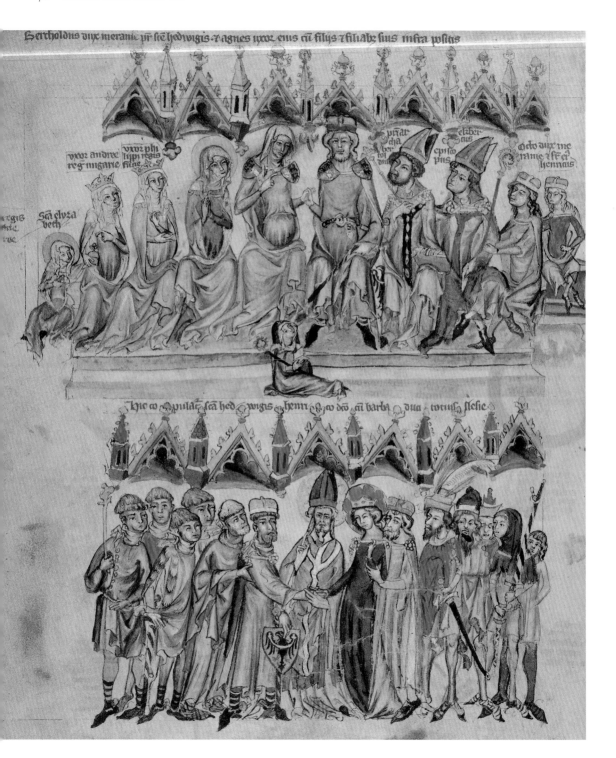

66 **The Family of Berthold VI; The**
Marriage of Saint Hedwig and Henry

Artist Unknown

The Life of the Blessed Hedwig

Silesia, Poland, 1353

JPGM, Ms. Ludwig XI 7 (83.MN.126),

fol. 10v

———

The lower portion of this page depicts the
marriage of Hedwig and Duke Henry of
Silesia. As in the *Feudal Customs of Aragon*
(see fig. 64), a priest physically joins their
hands in marriage as numerous witnesses
look on. Hedwig and Henry's fathers
embrace them during the ceremony, indi-
cating the parents' integral role in pairing
their children to create an advantageous
political alliance.

Hedwig's family is arranged above,
with her parents at center, her brothers at
right, Hedwig and her sisters at left and
at her parents' feet, and even her young
niece, Elizabeth of Hungary, who would
also become a saint, as indicated by her
halo (see fig. 30). Hedwig's genealogy was
of special importance to the patron of this
manuscript, Duke Ludwig I of Liegnitz
and Brieg, as he was a direct descendant of
the saint (see fig. 1).

67 **The Fourteenth Generation,**
Wilhelm Derrer

Artist Unknown

Genealogy of the Derrer Family

Nuremberg, about 1626–1711

JPGM, Ms. Ludwig XIII 12 (83.MP.155),

fol. 63v

———

This manuscript displays the various gen-
erations of the Derrer family, nobles from
Nuremberg. Following the paternal line,
each page clearly lays out one individual

generation of Derrers, whom the man
married and how many (or few) children
he and his wife had, and it also includes
those family members who became
priests, monks, or nuns. Shown here are
Wilhelm Derrer and his first wife, Ursula
Tetzlin, who bore no children, and his
second wife, Martha Heldin, from whom

a green stalk emerges that supports six
sets of Derrer coats of arms, representing
Wilhelm and Martha's six children. This
image is a direct, graphic acknowledg-
ment of the role of wives in producing
future generations of prominent medieval
European families.

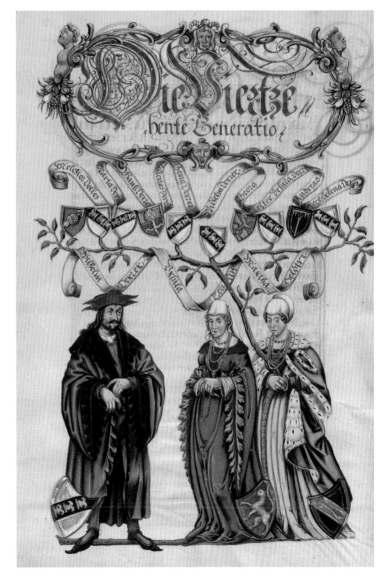

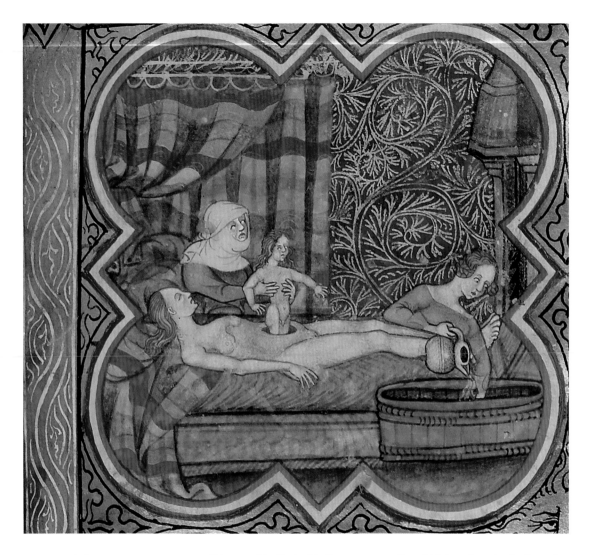

68 The Birth of Caesar

Artist Unknown

Deeds of the Romans

Paris, last quarter of the

fourteenth century

London, The British Library,

Royal Ms. 16 G VII, fol. 219

———

This copy of the *Deeds of the Romans* presents a graphic version of the birth of Julius Caesar, where he is shown being delivered through an incision made by a midwife in his dead mother's stomach. In the Middle Ages, this was a risky procedure, performed only when the mother had already expired. (In actuality, Caesar's mother didn't die.) The manner of Julius Caesar's birth was legendary by the medieval period, but it is unclear whether the term "Cesarean" was derived from Caesar's name or vice versa. Medieval images of women giving birth are unusual outside of medical treatises, and this example provides historical insight into the means and tribulations of childbirth for contemporary women.

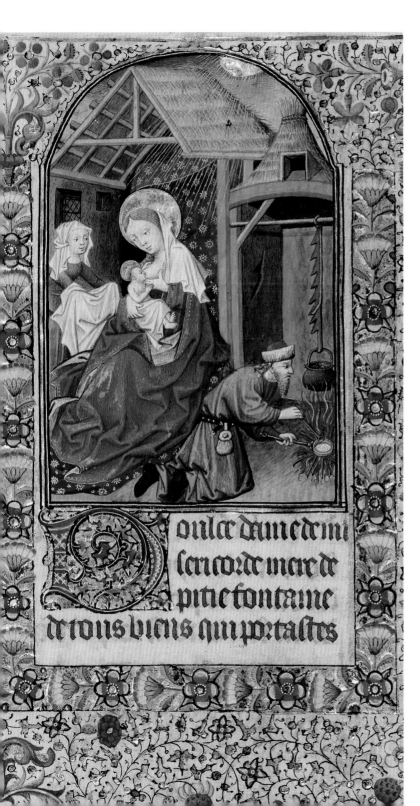

69 **The Holy Family**

Workshop of the Bedford Master

Book of hours

Paris, about 1440–50

JPGM, Ms. Ludwig IX 6 (83.ML.102),

fol. 181

In this cozy domestic setting, the Virgin
Mary nurses the Christ child while Joseph
kneels before a fire and stirs a pot of por-
ridge, a standard first food for babies. In
the later Middle Ages, Joseph was increas-
ingly emphasized as an active member of
the Holy Family and a central figure in
Christ's life. He was portrayed perform-
ing household tasks such as mending
garments, washing clothes, and preparing
meals for Jesus. Still, Joseph remained
marginalized, as indicated here by the lux-
urious cloth of honor on which only Mary
and Christ sit, and by his menial task,
which usually fell to women in the home.

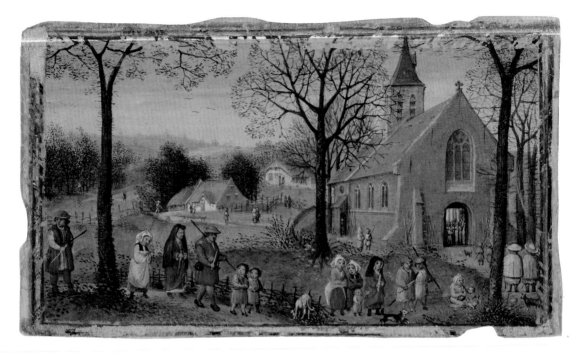

70 Villagers on Their Way to Church

Simon Bening

Calendar miniature from a book of hours

Bruges, about 1550

JPGM, Ms. 50 (93.MS.19), recto

———

This calendar scene from a book of hours presents a glimpse of life in a small northern European village in the late Middle Ages. The townspeople process to the local church—the nexus of town life—on the feast of Candlemas, the celebration of the Presentation of Christ in the Temple. Fathers and mothers hold candles and guide their children to the building, and one mother stops under a tree to feed her child a meal. This procession indicates the centrality of the family in village life, on a holiday that celebrates the Holy Family.

71 Initial *L*: The Baptism of Saint Augustine

Master of the Osservanza

Cutting from a choir book

Siena, about 1430

JPGM, Ms. 39 (90.MS.41), recto

———

Saint Augustine of Hippo was born in the fourth century to a pagan father and a Christian mother, and he received a Christian education. Nonetheless, he was never baptized as a child, and he experienced several periods of spiritual crisis during his early life. After his mother, Monica, encouraged him to abandon his heretical ideas and he heard the preaching of Ambrose, bishop of Milan, he finally decided to convert at age thirty-two. In this image, Saint Monica oversees her son's baptism by Saint Ambrose, showing the important role of the mother in the Christian spiritual life of her children, even in adulthood. The artist's balanced and intimately staged composition emphasizes the parity of the roles of Monica and Ambrose in Augustine's baptism.

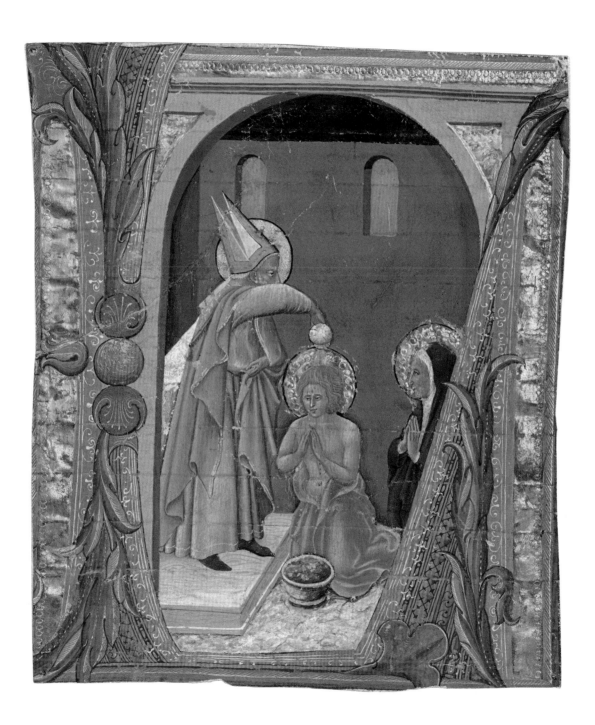

72 The Massacre of the Innocents

Artist Unknown

Llangattock Hours

Bruges and Ghent, 1450s

JPGM, Ms. Ludwig IX 7 (83.ML.103),

fol. 96v

After being informed by the three Magi
of the birth of Jesus, the king of the
Jews, King Herod feared that he would
be deposed and ordered all male chil-
dren in Bethlehem under the age of two
to be killed. The Massacre of the Inno-
cents that ensued became a popular sub-
ject in medieval imagery, and this example
in a Flemish book of hours sets the scene
in a townscape that reflects where the
manuscript was made. At left and right,
soldiers fatally stab naked children with
swords as their mothers struggle to protect
them. The woman at the center of the
scene weeps into her veil, expressing her
abject sorrow over her child lying lifeless
and dismembered on the ground.

73 The Seven Sorrows of the Virgin

Simon Bening

Prayer Book of Cardinal Albrecht of
Brandenburg

Bruges, about 1525–30

JPGM, Ms. Ludwig IX 19 (83.ML.115),
fol. 251v

The centerpiece of this miniature is the
seated figure of the Virgin Mary, sur-
rounded by seven swords that pierce her.
This devotional image was developed
during the Middle Ages to express Mary's
various sorrows as a mother who experi-
enced her son's abuse and suffering. The
surrounding scenes depict the Virgin's
presence at events in Christ's life when
she experienced emotional pain, such as
the Flight into Egypt, shown at lower left,
when Mary and Joseph fled their home to
avoid King Herod's order that all infant
boys be killed. Perhaps the most poignant
is the final scene of the Lamentation in
the upper right corner, where Mary weeps
over the bloodied figure of her dead son
laid across her lap, cradling him as if he
were an infant.

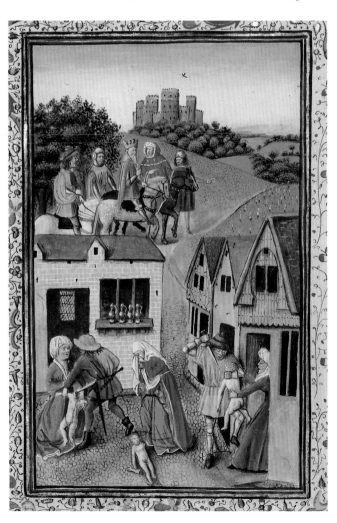

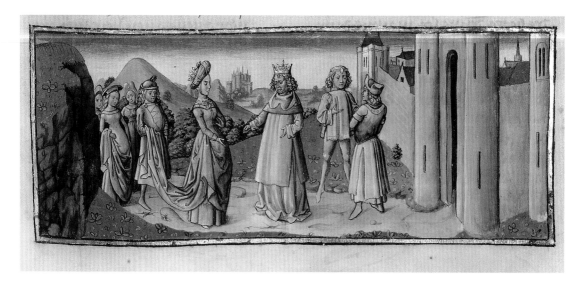

74 **Solomon and the Queen of Sheba**
Artist Unknown
Vincent de Beauvais, *Mirror of History*
Ghent, about 1475
JPGM, Ms. Ludwig XIII 5 (83.MP.148),
vol. 1, fol. 126

———

As the ruler of lands of great riches, the
queen of Sheba heard stories of the great-
ness of King Solomon and set out to pay
him a visit in Jerusalem. In this image,
the splendidly dressed, regal, stern queen
greets the king, and they converse as her
elaborate retinue looks on. Although not
illustrated here, the queen brought luxury
goods to give to Solomon, hoping to
secure economic relations in a key location
along the major trade route to the East.
The popularity of this story in the Middle
Ages suggests the increased role of women
in economic negotiations.

75 **Initial *Q*: A Woman with Bread**
Loaves before a Man Holding a Scale;
Initial *S*: The Baptism of a Moor
Artist Unknown
Vidal de Canellas, *Feudal Customs of Aragon*
Northeastern Spain, about 1290–1310
JPGM, Ms. Ludwig XIV 6 (83.MQ.165),
fol. 242v

———

In addition to the grand economic negoti-
ations undertaken by the queen of Sheba,
women participated in local economies as
well. The *Feudal Customs of Aragon* is an
Aragonese legal manuscript outlining rules
for various, sometimes contentious situa-
tions that arise in daily life (see fig. 64). In
the initial at upper left, a female baker lays
out her loaves of bread, which are weighed
and checked by a man with a scale. Some
have argued that her cross-legged seated
pose suggests that she is a Moor, a Muslim
from northwest Africa. This image therefore
suggests both the role of women in daily
trade in Aragon and also the interactions
and negotiations among various ethnic
groups in that society.

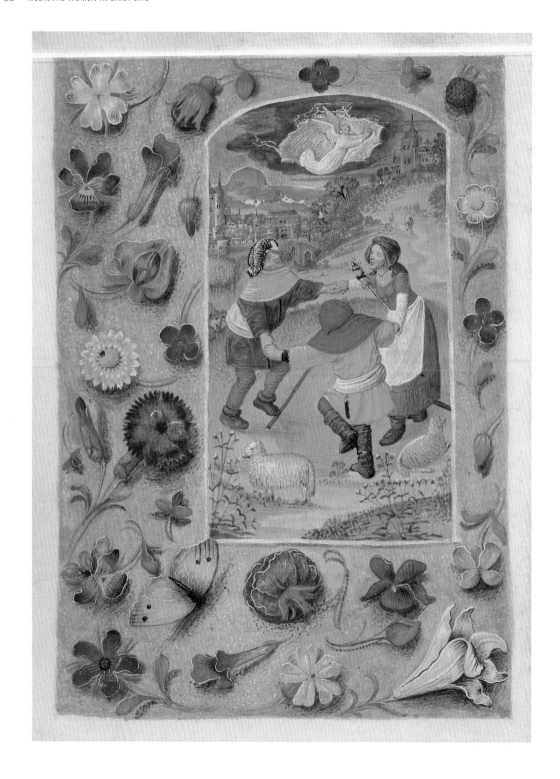

יקן טעמטר כנה של הה׳ | ול יושר וזמוג טעון הפ ה׳
תם תרומתו ותרוזה׳ כר בנועטר יקם עי הפיש ׳
וזעטריתז וזעטרות | ול שהוד פאורדהן התני פאור
הן הרועטר | ול התורם וזעטר כל שחורוזע לוי יתחל

שרחר שון דתרי בחלה חפריטי וחר וזעטרה חן הנ
ב חר | וחה הן הקרן וזעטר רלושון | ימר כי וחתרוע
וזעטר בב ישר יושר ירחן לי | וההעטרי הרה ל
לריס ובריס וקבות שב ולבו לי הנה טצר יותבל רוע

Although this image is based on the biblical
story of Christ's arrival being announced to
shepherds in the field, it foregrounds the
sheepherders themselves, dancing joyfully
in celebration of Jesus's birth. The woman
holds a distaff tucked in the waistband of
her apron, which highlights her role as
a spinner of wool from the flocks. This
occupation was of key importance in the
textile industry of northern Europe, where
this manuscript was made. The distaff also
recalls images of the Virgin Mary spinning
thread, an appropriate task for women at
all levels of society.

The *Mishneh Torah* is a compilation of
Jewish law texts composed in the twelfth
century by the Spanish rabbi Maimonides
(1135–1204). This miniature prefaces one
section of the chapter on agricultural
laws. A woman and a man dressed in
fifteenth-century Italian costume hold
produce from their fields and flank the
first words of the text. It states that after
separating out a special tithe for the

priests, another tithe ("the first tithe") is
taken, and both men and women of the
Levitical caste may partake of it. Although
Maimonides himself voiced reservations
about the education of women, the equity
between the sexes expressed through the
Talmudic passage and the symmetrical
composition of the image reflects the
prominence of women as scholars and
teachers, especially in the Ashkenazi Jew-
ish communities in early modern Italy.

ton orgueil ta luxure et
tes vanitez que tant tu
souloies amer · Queest
devenue ta vame leesse
Pourquoy ne faiz tu cha
ter danser et soulacier
ainsi come tu as cy devant
acoustume · Ou est a
present ton grant pouoir
par lequel a plusieurs tu
faysoies tort et Iniure
pourquoy ne le demous
tres tu point maintenant
pourquoy ne regarde
tu de tes yeulz comme tu
souloies · Ou sont les
beaulx boutes et mentiõs
dequoy tu souloies faire
tant grans festes et tant
de belles assemblees · Ou
sont maintenant tes pa
rens et amis charnielz
lesquelz tu souloies tant
amer / pourquoy ne les
appelles tu a cestuy dan
gier ou tu te retreuues
maintenant occupee et
desolee ·

Comment langele vint
qui reconforta lame de
tondal a sa grant necessite
Le chapitre ·

Quant lame entendi
le douloureux proces
que les dyables denfer
dedauoient contre elle
tant fut espouentee et
esbahie quelle ne savoit
que dire ne penser · Lame
estoit en telle desolation
come celle qui nattendoit
autre confort synon que
au partir du corps les en
nonce lemportassent es
tourmens perpetuelz ·

CHAPTER FOUR

MEDIEVAL WOMEN IN THE ARTS

argaret of York, of the English Plantagenet royal line, was renowned in
the Middle Ages for her small but lavish collection of books. During her
marriage of less than a decade to Charles the Bold, Margaret commis-
sioned at least eight manuscripts herself and owned at least sixteen others.
She marked them with her coat of arms, initials, motto, signature, or a
combination thereof. One of these volumes was an illuminated copy of
The Visions of the Knight Tondal, the story of an errant knight who jour-
neys through hell and heaven guided by an angel (fig. 78). This literary
selection may reflect her special devotion to the guardian angel, the cult
of which gained popularity in England in the fifteenth century. The left
margin of this page displays Margaret's initial intertwined with that of
her husband, and below, crossed scrolls with her motto: *Bien en adviengne*
(May good come of it).

Beyond new commissioned works and translations of texts into ver-
nacular languages, books of hours and prayer books were the most com-
mon types of manuscripts owned by women. These works were considered
to be appropriate possessions for wealthy Christian women, indicative
of their piety. Books of hours were the medieval bestseller, and female
patrons were influential in generating the great demand for their creation.
Women commissioned such books not just for themselves but also as gifts,
as in the case of Isabeau of Bavaria (see fig. 93), who gave prayer books
and primers to her children and the ladies of her court. Quite often these
prayer books for wealthy women were heavily illuminated, and numerous
female owners chose to have their portraits painted into their books, usu-
ally shown kneeling in prayer before the Virgin or a patron saint.

78 Tondal's Soul Enters Hell, Accompanied
 by His Guardian Angel
 Simon Marmion
 The Visions of the Knight Tondal
 Ghent and Valenciennes, 1475
 JPGM, Ms. 30 (87.MN.141), fol. 11v

Women who composed texts and painted images found in manuscripts were relatively few in the Middle Ages as compared to male authors and artists. However, the work of some extraordinary women, such as Christine de Pizan (see fig. 93) and Hildegard of Bingen (see fig. 94), was influential during the medieval period and is still widely read today. Christine, in particular, pointedly called into question the misogynist stereotypes widely held about women in the Middle Ages. In her most famous text, *The Book of the City of Ladies*, she wrote: "Not all men (and especially the wisest) share the opinion that it is bad for women to be educated. But it is very true that many foolish men have claimed this because it displeased them that women knew more than they did."

Although very few female artists from the Middle Ages are known to us by name, some records survive of their work in bookshops and ateliers. Still other women likely trained in manuscript workshops run by their fathers, and convents had scriptoria where nuns illuminated the manuscripts that they used in their daily prayer and devotion.

Detail, fig. 79

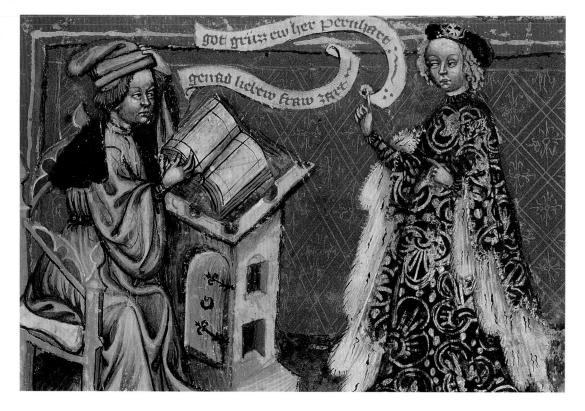

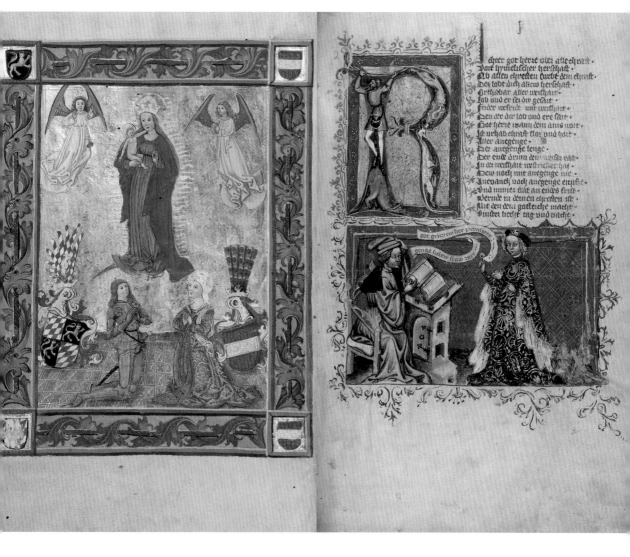

79 Duke Albrecht IV the Wise and His Wife, Kunigunde of Austria, Adoring the Virgin; A Scribe and a Woman

Artists Unknown

Rudolf von Ems, *World Chronicle*

Regensburg, about 1400–1410, with addition in 1487

JPGM, Ms. 33 (88.MP.70), fols. 2v–3

This heavily illustrated copy of Rudolf von Ems's *World Chronicle* begins with portraits of its early owners. On the right page, the noblewoman in resplendent patterned and fur-lined robes who addresses the scribe, Bernhart, is likely the original commissioner of the book. About eighty years later it entered the collection of Duke Albrecht IV the Wise and Kunigunde of Austria, who added not only portraits of themselves kneeling and adoring the Virgin Mary on the left page but also their Bavaria-Palatinate (left) and Habsburg (right) coats of arms. The early female owners of this book therefore added elements of their identities to integrate themselves into the manuscript.

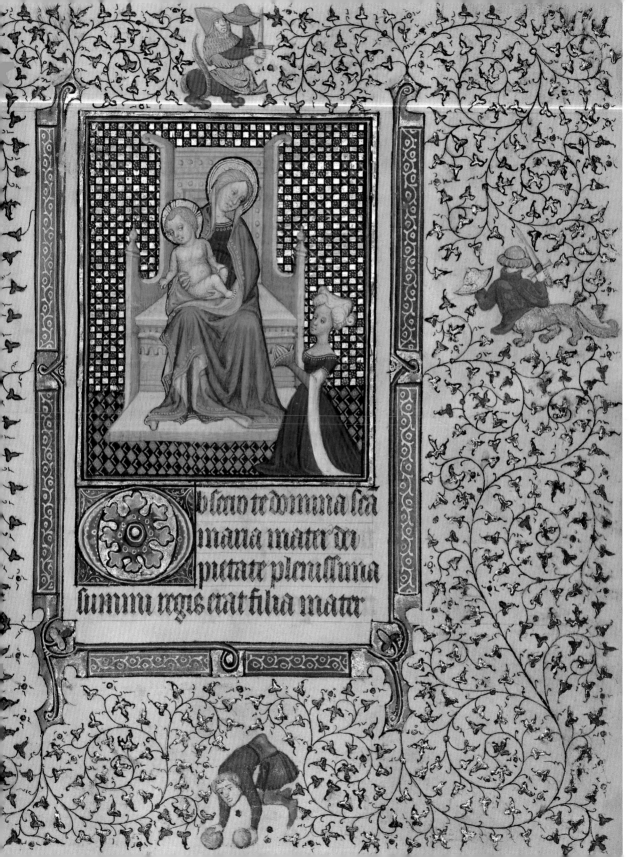

b lato te dominia sea
maria mater di
pietate plenissima
summi regis erat filia mater

80 | 81

A Woman in Prayer before the Virgin
and Child | The Virgin and Child
and a Woman in Prayer
Follower of the Egerton Master
Book of hours
Paris, about 1410
JPGM, Ms. Ludwig IX 5 (83.ML.101),
fols. 19 and 23

———

This book of hours contains two portraits
of its female owner prefacing prayers to
the Virgin Mary (figs. 80, 81). Devotion
to the Virgin was common among men
and women alike, but this was especially
true for women because of Mary's role as
a mother. In each of the two images, the
patron wears an elaborate hairstyle and a
style of gown fashionable at the time. This
bespeaks her wealth and prestige, both of
which made it possible for her to own a
luxurious illuminated prayer book such
as this.

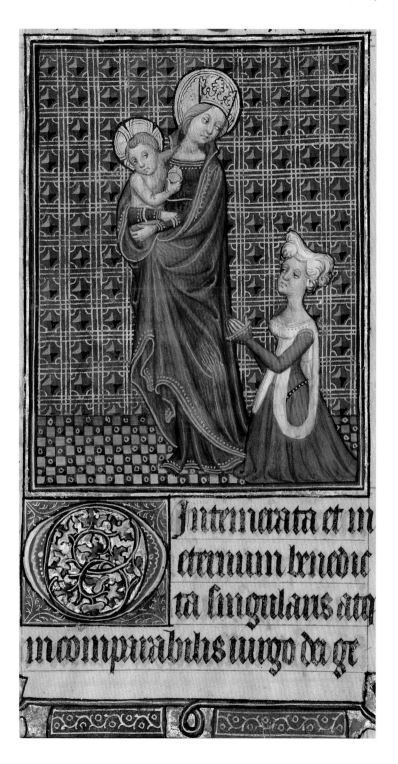

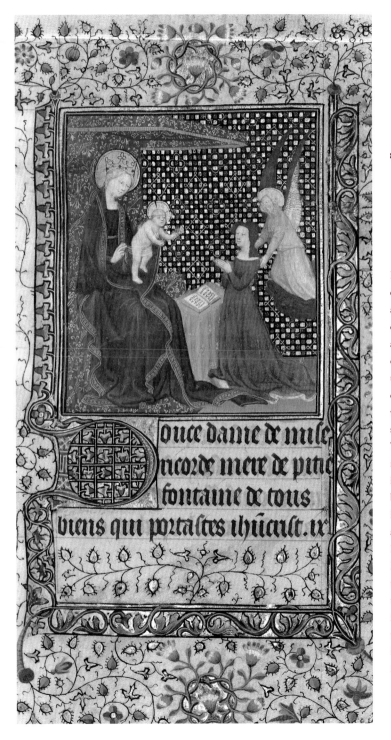

**82 A Patron Presented to the Virgin
and Child**

Boucicaut Master and Workshop

Book of hours

Paris, about 1415–20

JPGM, Ms. 22 (86.ML.571), fol. 137

Here, an angel hovers above the figure
of a laywoman who kneels praying from
a book of hours at her prie-dieu (prayer
desk). Before her is a vision of the Virgin
and Child enthroned under a lavish textile
canopy, indicating her great devotion
to the Virgin. In contrast to the richly
dressed laywoman shown in the previous
works (see figs. 80, 81), this patron wears a
simple outfit with no elaborate trimmings.
This may be an indication of late medieval
regulations curbing excessive decoration
in women's dress. Conversely, this prayer
book is filled with beautifully painted
images executed by one of the most skilled
and sought-after painters who worked in
Paris around the year 1400, the Boucicaut
Master and his workshop. While the iden-
tity of the female patron is not known,
the artist may have left hints: embedded
in the elaborate borders of this page are
three daisies, which are called *marguerite*
in French and may suggest that her name
is Margaret.

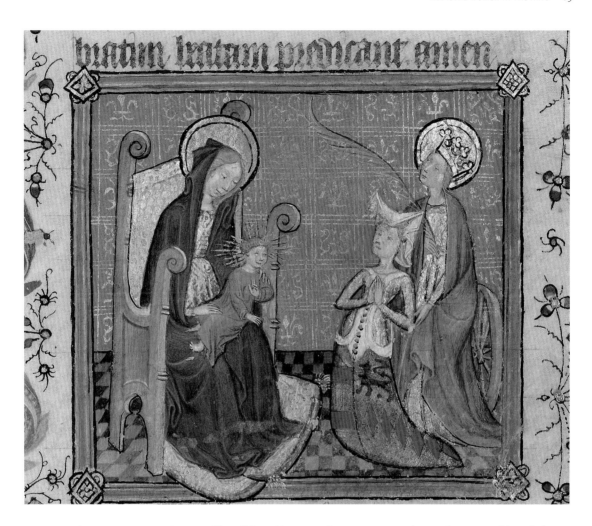

83 Saint Catherine Presenting a Kneeling
 Woman to the Virgin and Child
 Artist Unknown
 Book of hours
 Paris or Le Mans, about 1400–1410
 JPGM, Ms. Ludwig IX 4 (83.ML.100),
 fol. 105

The well-dressed laywoman shown
kneeling is presented to the Virgin and
Child by Saint Catherine, identified by
the wheel on which she was tortured
(see figs. 24, 25). Catherine acts as an
intercessor on behalf of the patron in this
image that prefaces a prayer to the Virgin
written in the owner's native French.
Although the identity of the patron is

unknown, the presence of Saint Catherine
suggests that her name may have also
been Catherine. At the very least, it is an
indication of her devotion to the saint
and a testament to the holy woman's
popularity in the Middle Ages. The
patron's unusual silver skirt is decorated
with a pattern that is likely drawn from
her family's coat of arms.

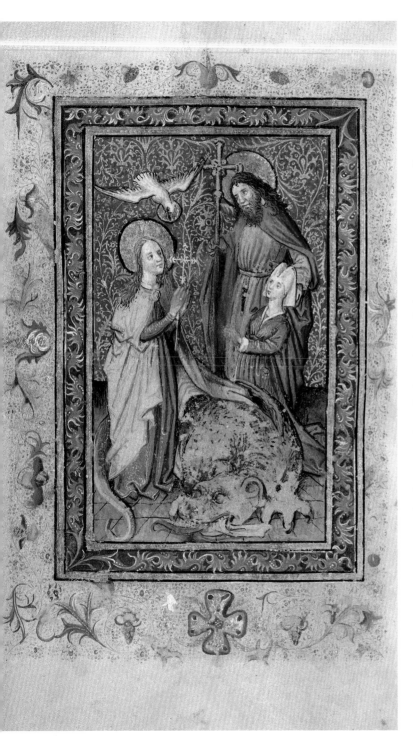

84 A Bearded Saint with Cruciform Staff Presenting a Kneeling Woman to Saint Margaret

Book of hours

Possibly Brabant, after 1460

JPGM, Ms. Ludwig IX 9 (83.ML.105), fol. 13v

As in the image of the female patron with the Virgin and Saint Catherine (see fig. 83), this laywoman is presented to a patron saint by another holy figure who intercedes on her behalf. The figure of Saint Margaret is recognizable by the dragon that curls around her, recalling the story of how she was devoured by the beast and cut herself free with the cross that she holds (see fig. 26). Although the male saint is unidentified, his cross-shaped staff points to his identification as Saint John the Baptist. The female and male saints present here demonstrate that medieval Christian women professed devotion to saints of both genders.

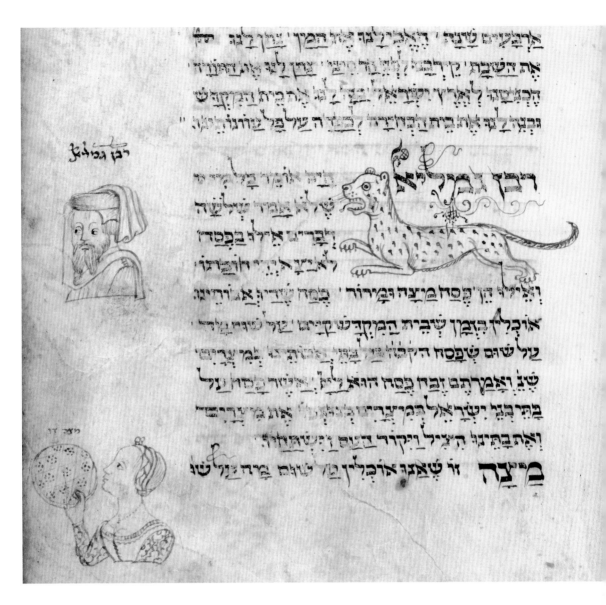

אַרְבָּעִים שָׁנָה רַבִּי אֱלִיעֶזֶר בֶּן עֲזַרְיָה וַהֲלֹא לֹא זָכִיתִי שֶׁתֵּאָמֵר יְצִיאַת מִצְרַיִם בַּלֵּילוֹת עַד שֶׁדְּרָשָׁהּ בֶּן זוֹמָא

רַבָּן גַּמְלִיאֵל

רַבָּן גַּמְלִיאֵל הָיָה אוֹמֵר כָּל שֶׁלֹּא אָמַר שְׁלֹשָׁה דְבָרִים אֵלּוּ בְּפֶסַח לֹא יָצָא יְדֵי חוֹבָתוֹ וְאֵלּוּ הֵן פֶּסַח מַצָּה וּמָרוֹר פֶּסַח שֶׁהָיוּ אֲבוֹתֵינוּ

אוֹכְלִין בִּזְמַן שֶׁבֵּית הַמִּקְדָּשׁ קַיָּם עַל שׁוּם מָה עַל שׁוּם שֶׁפָּסַח הַקָּדוֹשׁ בָּרוּךְ הוּא עַל בָּתֵּי אֲבוֹתֵינוּ בְּמִצְרַיִם שֶׁנֶּאֱמַר וַאֲמַרְתֶּם זֶבַח פֶּסַח הוּא לַיְיָ אֲשֶׁר פָּסַח עַל בָּתֵּי בְנֵי יִשְׂרָאֵל בְּמִצְרַיִם בְּנָגְפּוֹ אֶת מִצְרַיִם וְאֶת בָּתֵּינוּ הִצִּיל וַיִּקֹּד הָעָם וַיִּשְׁתַּחֲווּ

מַצָּה זוֹ שֶׁאָנוּ אוֹכְלִין עַל שׁוּם מָה עַל שׁוּם

85 Maraviglia with a Matzo

Joel ben Simeon Feibush
Prayer book
Northern Italy, 1469
London, The British Library, Add.
Ms. 26957, fol. 45

The colophon to this prayer book states that it was commissioned by Menahem ben Samuel for his daughter Maraviglia. The manuscript contains a Haggadah, the book of prayers read from during the Passover Seder. One page from this section displays a marginal drawing of a woman dressed at the height of fifteenth-century Italian fashion holding a round matzo, or unleavened bread. She likely represents Maraviglia, and her image not only functions as a portrait of a patron but also emphasizes the role of Jewish women in the Seder and as owners of the books used to perform the ceremony.

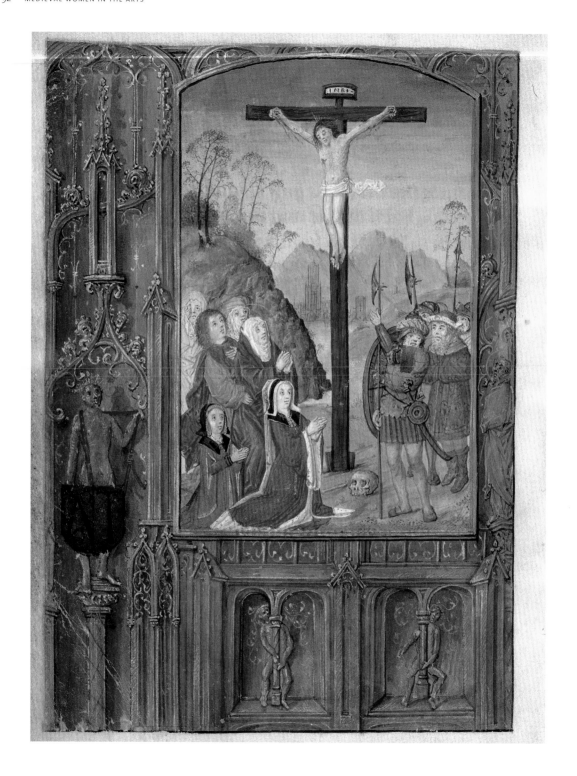

86 | 87

The Crucifixion with a Kneeling Woman
| Initial *O*: A Woman Receiving
Communion
Workshop of Gerard Horenbout
Book of hours
Possibly Ghent and Cologne, about 1500
JPGM, Ms. Ludwig IX 17 (83.ML.113),
fols. 86v and 113v

———

A well-dressed laywoman appears at the
foot of the cross in a scene of Christ's
Crucifixion in this German book of hours
(fig. 86). Behind her is a similarly dressed
woman, probably her daughter, who
likely would have inherited this prayer
book after her mother's death. In the left
margin, a coat of arms hangs from a nude
figure's neck. This shield, along with the
female donor portraits, offer a clue that
this book of hours was created for a female
member of the Van Aussem family of
Cologne. Unlike the female patrons shown
previously who appear accompanied by
a saint (see figs. 83, 84), this woman and
her daughter have been inserted directly
and anachronistically into the biblical
narrative of Christ's death. This image
may represent their mental vision of the
Crucifixion conjured up by their prayer
and meditation, giving them privileged
access to this event of central importance
to Christian belief. Later in the manu-
script, in front of the high altar within a
grand church, the same laywoman kneels
before a priest who elevates a host as she
prepares to receive Communion (fig. 87).
This image would have reminded the
patron of an integral part of Christian
devotional practice—the consumption
of the Eucharist—as she read the book
during her daily private prayer.

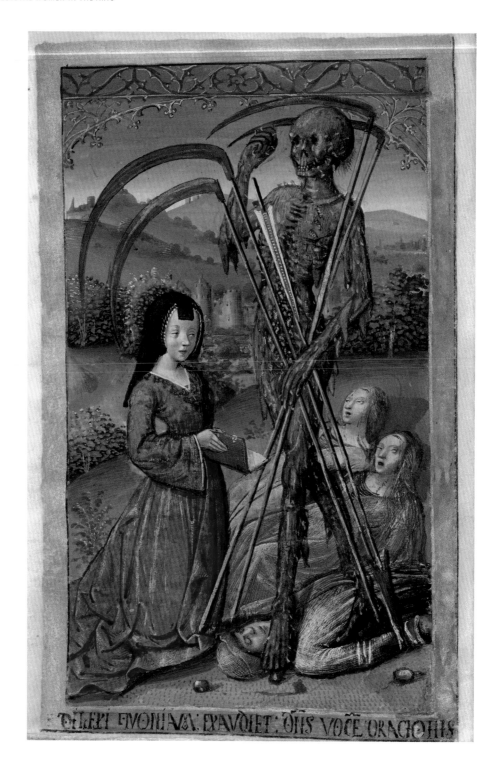

88 **Denise Poncher before a Vision of Death**

Master of the *Chroniques scandaleuse*

Poncher Hours

Paris, about 1500

JPGM, Ms. 109 (2011.40), fol. 156

———

The beautiful young owner of this manu-
script, Denise Poncher, was memorialized
in this striking portrait. As in other images
of patrons, she kneels on the ground,
praying from her book of hours, but
rather than a patron saint, the horrific
figure of the maggot-infested Death looms
above her, holding multiple scythes.
Instead of indicating her devotional atten-
tions, this portrait lays bare the ephemeral
nature of life, as shown by the man and
two youthful women on the ground who
have already met their demise. Denise
came from a high-ranking Parisian family;
her father was the treasurer of wars for the
king of France, and her uncle was bishop
of Paris. Thus, a lavish prayer book such
as this one would have been an appro-
priate object for a woman of her class to
own. Some of the manuscript's pages are
marked with her coat of arms combined
with those of her husband, Jean Brosset,
and this book also contains several images
related to marriage and motherhood,
which suggests that it may have been
commissioned on the occasion of her
wedding. Maternal mortality rates were
high in the Middle Ages; the image of
Death may have acted as a reminder to
the youthful Denise of the potential
dangers of motherhood.

89 **Saint Bellinus Celebrating Mass**

Taddeo Crivelli

Gualenghi-d'Este Hours

Ferrara, about 1469

JPGM, Ms. Ludwig IX 13 (83.ML.109),
fol. 190v

———

This manuscript takes its name from the
union of two powerful northern Italian
ruling families (Gualengo and Este) estab-
lished through the marriage of the book's

patrons. The husband and wife who owned
this book of hours appear here in an image
of the bishop of Padua, Saint Bellinus, cel-
ebrating Mass in a marble-walled chapel.
Although Orsina d'Este seems secondary
to her husband, Andrea Gualengo, in the
illustration, in reality, her identity and
family line are presented prominently, as
the two young boys are likely her sons
from a previous marriage.

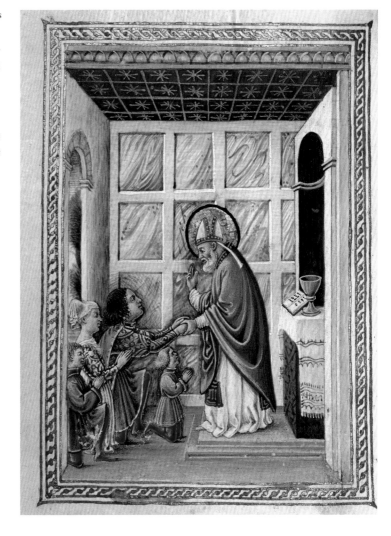

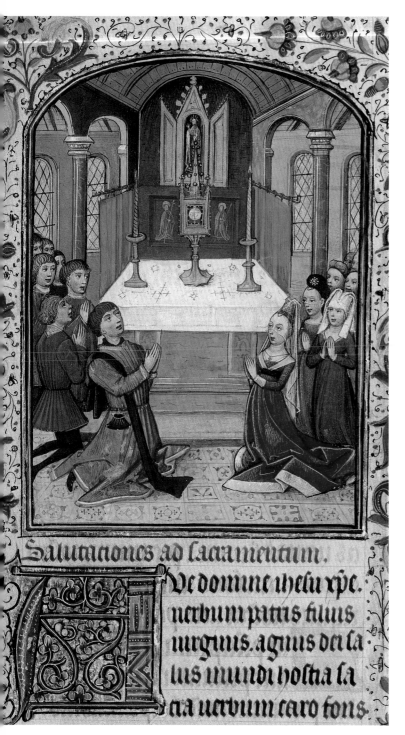

90 The Adoration of the Eucharist

Willem Vrelant

Arenberg Hours

Bruges, early 1460s

JPGM, Ms. Ludwig IX 8 (83.ML.104),

fol. 144

———

In this image, a wealthy man and woman
kneel before the Eucharist, displayed in
an elaborate monstrance on an altar. They
each head up a group of men and women,
respectively, probably members of their
court or household. This same couple is also
presented in an initial found earlier in the
manuscript (see fig. 34); they likely repre-
sent the husband and wife who owned this
book. They stand as examples of the appro-
priately pious behavior that was expected of
Christians in the presence of the Eucharist.

91 The Gates of Hell and Lucifer

Simon Marmion

The Visions of the Knight Tondal

Ghent and Valenciennes, 1475

JPGM, Ms. 30 (87.MN.141), fol. 30v

———

In addition to their portraits, sometimes
patrons marked the books they commis-
sioned with a more abstract symbol of
their ownership, such as a coat of arms
or a motto. The borders of many pages in
The Visions of the Knight Tondal display the
letters *C* and *M* tied together with a blue
rope reminiscent of the love knot used to
bind the hands of couples getting married
in the Middle Ages. These are the initials
of Margaret of York, Duchess of Burgundy,
and her husband, Charles the Bold (see
fig. 78). Margaret was a great manuscript
collector, and she commissioned this, the
only surviving illuminated copy of the story
of the knight Tondal.

Comment langele de nre
seigneur mena lame du
chaalier tondal dedens les
portes denfer ou ilz veient
lucifer z coment par luy
sont les ames tourmentee!
De la grant horriblete de
tourmens ou la sont. Et
coment langele et lame
passerent oult? Le c?

Uant lame du che
uallier tondal fut
come dit est par
langele deliure de la ci-
terne aidant et reconfortee

Langele de redref luy
dist viench auant et re
te moustreray le tres de
testable et horrible ancie
enemy del humain lig
nage. Si aloit langele
deuant. Et lame apres
Et tant alerent que ilz
vindrent a la porte defer
Adont dist langele al
ame viench et esgarde
Lame approcha tant qlle
vist la grant porte defer
Et selle eust en cent tes
tes cent peulx et autat

92 Initial *G*: The Death of the Virgin

Jacobellus of Salerno

Gradual

Bologna, about 1270

JPGM, Ms. Ludwig VI 1 (83.MH.84),

fol. 48v

The lower margin of this page offers insight into worship in a Dominican convent. Female monastics required visiting priests to celebrate the Mass (as signified by the friars before the altar at left), but the nuns could provide musical accompaniment. Here, they sing from a choir book placed on a stand and read from individual books, mirroring how this gradual would have been used in the liturgy. The feast of the Virgin Mary's Assumption, represented by her Dormition in the initial above, must have held particular devotional importance for the nuns who owned and sang from this book, since this is one of the most elaborately decorated pages in the manuscript.

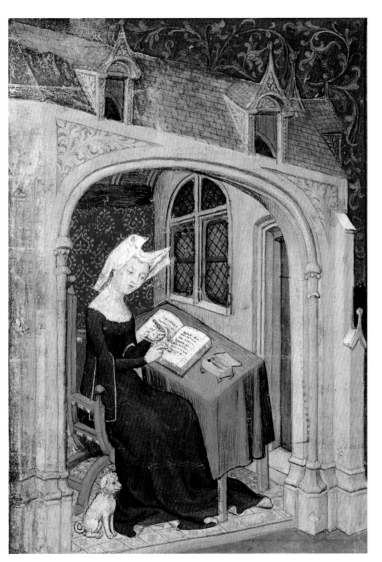

93 **Christine de Pizan**

Master of the *Cité des Dames*
and Workshop
Christine de Pizan, *The Book of the Queen*
Paris, 1410–14
London, The British Library, Harley
Ms. 4431, fol. 4

Christine de Pizan, one of the earliest
known professional female authors,
attracted the patronage of the French
royal court and the dukes of Burgundy.
The Book of the Queen was compiled for
a powerful female patron, Isabeau of
Bavaria, wife of Charles VI of France, and
Christine may have acted as scribe for
some passages. This portrait of the author
seated at her desk writing her text appears
at the beginning of the manuscript pref-
acing a collection of one hundred love
poems. It is a reminder of Christine's
integral role in creating, producing, and
distributing her numerous literary works.
She represents the bastion of literature
written by women, a genre that flourished
particularly in the French vernacular.

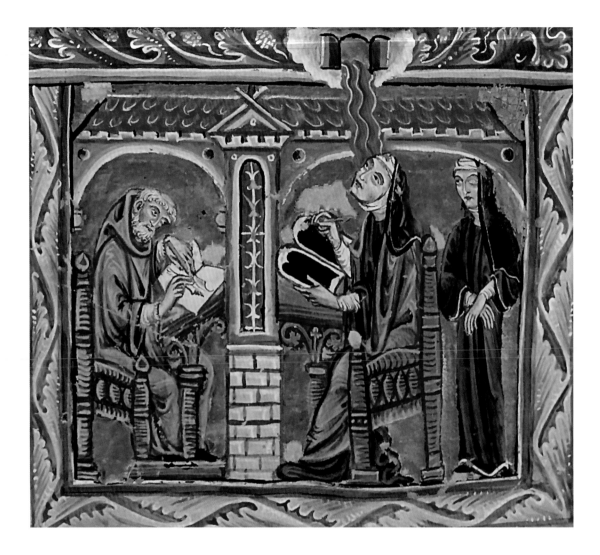

94 Hildegard of Bingen Receiving a Vision

Artist Unknown

Hildegard of Bingen, *Book of Divine Works*

Rupertsberg, about 1220–30

Lucca, Biblioteca Statale di Lucca, Ms. 1942, c.IV (Membr. sec. XIII)

———

Hildegard of Bingen was a twelfth-century nun famous for her visions, which she wrote down and were eventually published. She also composed music and plays and supervised the illumination of some copies of her text. This copy of her final manuscript, the *Book of Divine Works,* begins with an image of Hildegard receiving a vision in the presence of her secretary, Volmar, and her confidante, Richardis. Hildegard records what she sees on the wax tablets open before her on the desk. The text features the female personifications of Charity and Wisdom (see figs. 36, 37) as well as figures from the book of Revelation (see figs. 51–53). In 2012 Hildegard was named the fourth female Doctor of the Church, becoming a member of a group of sainted individuals who made major contributions to Christian doctrine through their theological writings.

95 Lancelot Rescuing a Demoiselle
from Brehus sans Pitié
Jeanne de Montbaston
Romance of the Good Knight Tristan
Paris, about 1320–40
JPGM, Ms. Ludwig XV 5 (83.MR.175),
fol. 298

Jeanne de Montbaston was a Parisian
bookseller and illuminator who, with her
husband, Richard de Montbaston, ran a
workshop on the rue Neuve-Notre-Dame
in Paris that produced at least fifty illumi-
nated manuscripts from before 1338 until
sometime after 1353. The couple specialized
in vernacular literary texts, particularly
the popular *Romance of the Rose*, of which
they produced nineteen copies. Jeanne was
responsible for several illuminations in this
copy of the *Romance of the Good Knight
Tristan*, illustrating such subjects as sword
fights, knights jousting, tournaments, and
damsels being rescued. After Richard's
death around 1353, Jeanne swore an oath
to the university in Paris in order to con-
tinue working as a bookseller in the city.
It is believed that the wives (and children)
of male artisans frequently assisted in their
workshops; however, these women's names
were rarely recorded.

96 Initial *Q*: Claricia

Artist Unknown

Claricia Psalter

Augsburg, late twelfth–early

thirteenth century

Baltimore, Walters Art Museum,

Ms. 26, fol. 64

The figure of a woman in a flowing dress
that forms the tail of this initial *Q* is
inscribed with the name "Claricia." This
manuscript was likely made for the Bene-
dictine abbey of Saint Ulrich and Afra in
Augsburg; supporting this identification
is a second initial in the book decorated
with a figure of a nun in a habit. Claricia's
secular dress, uncovered head, and flowing
hair indicate that she is a laywoman, and
it has been suggested that she may have
been one of the artists responsible for this
manuscript's illuminations.

97 Embroidered Hanging

Artist Unknown

Possibly Hildesheim, late fourteenth
century

New York, The Metropolitan Museum
of Art, The Cloisters Collection,
Gift of Mrs. W. Murray Crane, 69.106

While the work of female artists in the
realm of manuscript illumination is rel-
atively unknown to us today, evidence
of women's skill in other crafts, such as
needlework and embroidery, is more
abundant (see figs. 16, 47, 76). This elabo-
rate example was likely produced by nuns
at the German convent of Weinhausen for

noble patrons whose coats of arms appear
in the upper and lower borders. The
complex subject matter pairs scenes from
the Hebrew Bible and the Christian New
Testament, such as the juxtaposition of the
Flowering of Aaron's Rod and the Annun-
ciation at upper left.

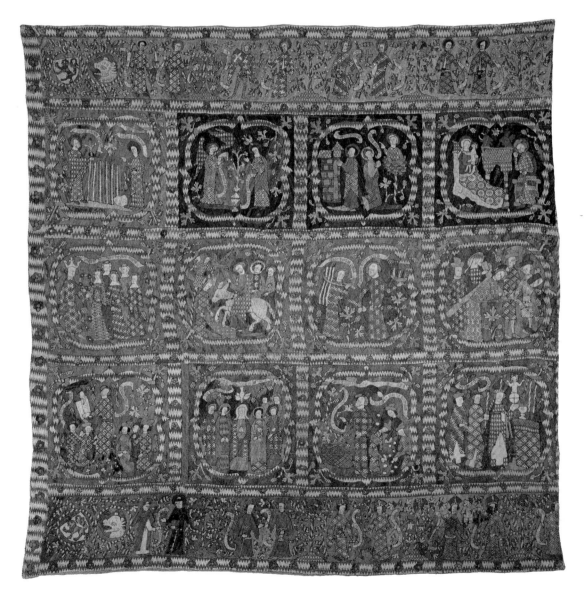

THE STORY OF A HUNTER

EPILOGUE

The Middle Ages looms large in the modern imagination. The nineteenth and early twentieth centuries saw a renewed interest in the study and revival of medieval art and architecture in both Europe and America, an interest that has continued to the present day. Some female artists have continued the traditions and techniques of manuscript illumination or revisited subject matter typically found in medieval manuscripts, demonstrating an enduring fascination with the medieval expression of womanhood in its many facets.

98 A Hunter Standing in Reeds and Seeing
a Reflection of a White Bird in the Water
Florence Kingsford Cockerell
Olive Schreiner, *The Story of a Hunter*
England, 1908
JPGM, Ms. Ludwig XV 12 (83.MR.182),
fol. 4v

———

This miniature is the frontispiece of an extraordinary manuscript copy of *The Story of a Hunter,* which was originally published in 1883 by Olive Schreiner, a female author who sometimes wrote under the male pseudonym Ralph Iron. It was illuminated by Florence Kingsford Cockerell, a painter who trained in techniques of medieval manuscript illumination, such as the application of gold leaf to parchment, as seen in the words of the title on this page. This manuscript represents a recasting of two predominantly male pursuits in the Middle Ages—writing and illuminating—by a female hand.

99 Matzo and Bitter Herbs

Barbara Wolff

The Rose Haggadah

New York, 2011–13

New York, The Morgan Library &
Museum, Gift of Joanna S. Rose, 2014,
Ms. M.1191, pp. 8–9

Working in the centuries-long tradition
of illustrated Haggadot, Barbara Wolff
illuminated this twenty-first century
copy of the text read during the Passover
Seder. Her artistic practice incorporates
the prominent use of gold and silver leaf,
reflecting the heritage of medieval man-
uscript illumination. In addition, several
of the pages display English captions,

which were penned by a female calligra-
pher named Karen Gorst. The images of
matzo and bitter herbs shown here recall
the portrait of Maraviglia holding a matzo
in a fifteenth-century Italian Haggadah
(see fig. 85). This modern Hebrew book
reinforces the important role that women
continue to play in the commissioning,
creation, and use of manuscripts.

This is the bread of poverty
which our forefathers ate in
the land of Egypt

Why is this night different
from all other nights?

100 The Three Marys

Julia Margaret Cameron
Albumen silver print
Freshwater, England, 1864
JPGM, 84.XZ.186.108

A pioneer at the dawn of photography, Julia Margaret Cameron also broke ground as a female practitioner of this new medium. Though her technique was thoroughly modern, the subjects she treated and the way she composed them often recall medieval manuscript imagery. In this photograph, Cameron, a devout Christian, calls to mind the three Marys who visited Christ's grave to anoint his body, only to discover that the tomb was empty (see fig. 56). The artist dressed her models (who were all named Mary) in draped garments covering their heads, evoking women's dress at the time of Christ. Cameron's sensitive treatment expresses the women's sorrow and incredulity at finding Christ gone and echoes the treatment of similar scenes in medieval manuscripts.

SUGGESTIONS FOR FURTHER READING

Bennett, Judith M., and Ruth Mazo Karras. *The Oxford Hand-book of Women and Gender in Medieval Europe*. Oxford: Oxford University Press, 2013.

Buettner, Brigitte. "Women and the Circulation of Books." *Journal of the Early Book Society for the Study of Manuscripts and Printing History* 4 (2001): 9–31.

Green, D. H. *Women Readers in the Middle Ages*. Cambridge: Cambridge University Press, 2007.

Grössinger, Christa. *Picturing Women in Late Medieval and Renaissance Art*. Manchester and New York: Manchester University Press, 1997.

Hand, Joni M. *Women, Manuscripts and Identity in Northern Europe, 1350–1550*. Farnham, Surrey, England; Burlington, VT: Ashgate, 2013.

Jackson, Deirdre. *Medieval Women*. London: The British Library, 2015.

Martin, Therese, ed. *Reassessing the Roles of Women as "Makers" of Medieval Art and Architecture*. 2 vols. Leiden: Brill, 2012.

McCash, June Hall, ed. *The Cultural Patronage of Medieval Women*. Athens and London: University of Georgia Press, 1996.

Schaus, Margaret. *Women and Gender in Medieval Europe: An Encyclopedia*. New York: Routledge, 2006.

Smith, Lesley, and Jane H. M. Taylor, eds. *Women and the Book: Assessing the Visual Evidence*. London and Toronto: The British Library and University of Toronto Press, 1996.

Ward, Jennifer C. *Women in Medieval Europe, 1200–1500*. London and New York: Longman, 2002.

Online Resource

Feminae: Medieval Women and Gender Index. https://inpress.lib.uiowa.edu/feminae/WhatIsFeminae.aspx

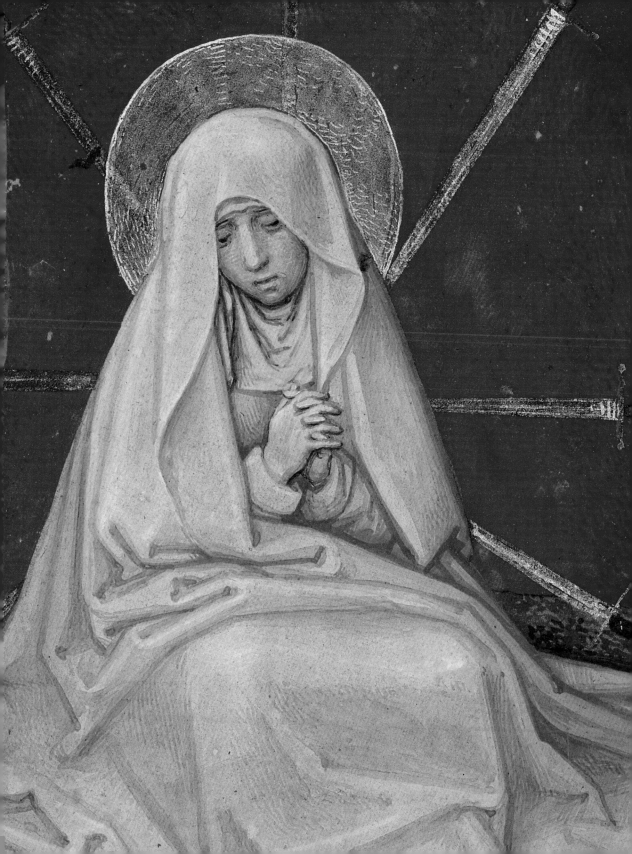

This publication is issued on the occasion of the exhibition *Illuminating Women in the Medieval World*, on view at the J. Paul Getty Museum at the Getty Center, Los Angeles, from June 20 to September 17, 2017.

© 2017 J. Paul Getty Trust

Published by the J. Paul Getty Museum, Los Angeles
Getty Publications
1200 Getty Center Drive, Suite 500
Los Angeles, California 90049-1682
www.getty.edu/publications

Ruth Evans Lane and Rachel Barth, *Editors*
Kurt Hauser, *Designer*
Amita Molloy, *Production*

Distributed in the United States and Canada by
the University of Chicago Press

Distributed outside the United States and Canada by
Yale University Press, London

Printed in Italy

Library of Congress Cataloging-in-Publication Data
Names: Sciacca, Christine, 1976– author. | J. Paul Getty
 Museum, issuing body.
Title: Illuminating women in the medieval world /
 Christine Sciacca.
Description: Los Angeles : J. Paul Getty Museum, [2017]
Identifiers: LCCN 2016047239 | ISBN 9781606065266
 (hardcover)
Subjects: LCSH: Women in art. | Women—History—
 Middle Ages, 500–1500—Pictorial works. | Illumination of
 books and manuscripts, Medieval.
Classification: LCC HQ1143 S35 2017 | DDC 305.409/02—dc23
LC record available at https://lccn.loc.gov/2016047239

Front jacket: Mary Magdalene with a Book and an Ointment Jar, Workshop of the Master of the First Prayer Book of Maximilian, Spinola Hours, about 1510–20 (detail, fig. 5)

Back jacket, left: Saint Hedwig of Silesia with Duke Ludwig I of Liegnitz and Brieg and Duchess Agnes, artist unknown, 1353 (detail, fig. 1); right: Saint Margaret, Lieven van Lathem, 1469 (detail, fig. 26)

Page i: Denise Poncher before a Vision of Death, Master of the *Chroniques scandaleuse*, about 1500 (detail, fig. 88)

Pages ii–iii: Women Reading and the Passover Seder, artist unknown, first half of the fifteenth century (detail, fig. 8)

Page iv, left: Jael Slaying Sisera (Judith Slaying Holofernes), Follower of Hans Schilling from the Workshop of Diebold Lauber, 1469 (detail, fig. 15); right: Bathsheba Bathing, Jean Bourdichon, 1498–99 (detail, fig. 42)

Page v, left: The Marriage of Louis de Blois and Marie de France, Master of the Getty Froissart, about 1480–83 (detail, fig. 65); right: Christine de Pizan, Master of the *Cité des Dames* and Workshop, 1410–14 (detail, fig. 93)

Page vi: Euryalus Sends His First Letter to Lucretia, artist unknown, about 1460–70 (detail, fig. 61)

Page viii: Saint Hedwig and the New Convent; Nuns from Bamberg Settling at the New Convent, artist unknown, 1353 (detail, fig. 29)

Page 109: The Seven Sorrows of the Virgin, Simon Bening, about 1525–30 (detail, fig. 73)

Illustration Credits

Fig. 8: Darmstadt, Universitäts- und Landesbibliothek, Cod. Or. 8, fol. 37v

Figs. 13, 99: The Pierpont Morgan Library, New York

Figs. 20, 44: Randy Dodson

Fig. 27: Bibliothèque nationale de France

Fig. 30: The Huntington Library, San Marino, California

Fig. 31: Musée Dobrée–Grand Patrimoine de Loire-Atlantique / Photo © C. Hémon

Figs. 35, 77, 97: www.metmuseum.org

Fig. 59: Digital Imaging by DIAMM (www.diamm.ac.uk) by kind permission of the Ferrell Collection

Figs. 68, 93: © British Library Board / Robana / Art Resource, NY

Fig. 85: British Library, London, UK / Bridgeman Images

Fig. 94: Lucca, Biblioteca Statale, Ms. 1942, c.1v / Su concessione del Ministero dei Beni, le Attività culturali e del Turismo

Fig. 96: The Walters Art Museum, Baltimore

Note to the reader: the abbreviation "JPGM" refers to the J. Paul Getty Museum.